ZACK CARR

BY GEORGE CARR

pH powerHouse Books
NEW YORK, NY

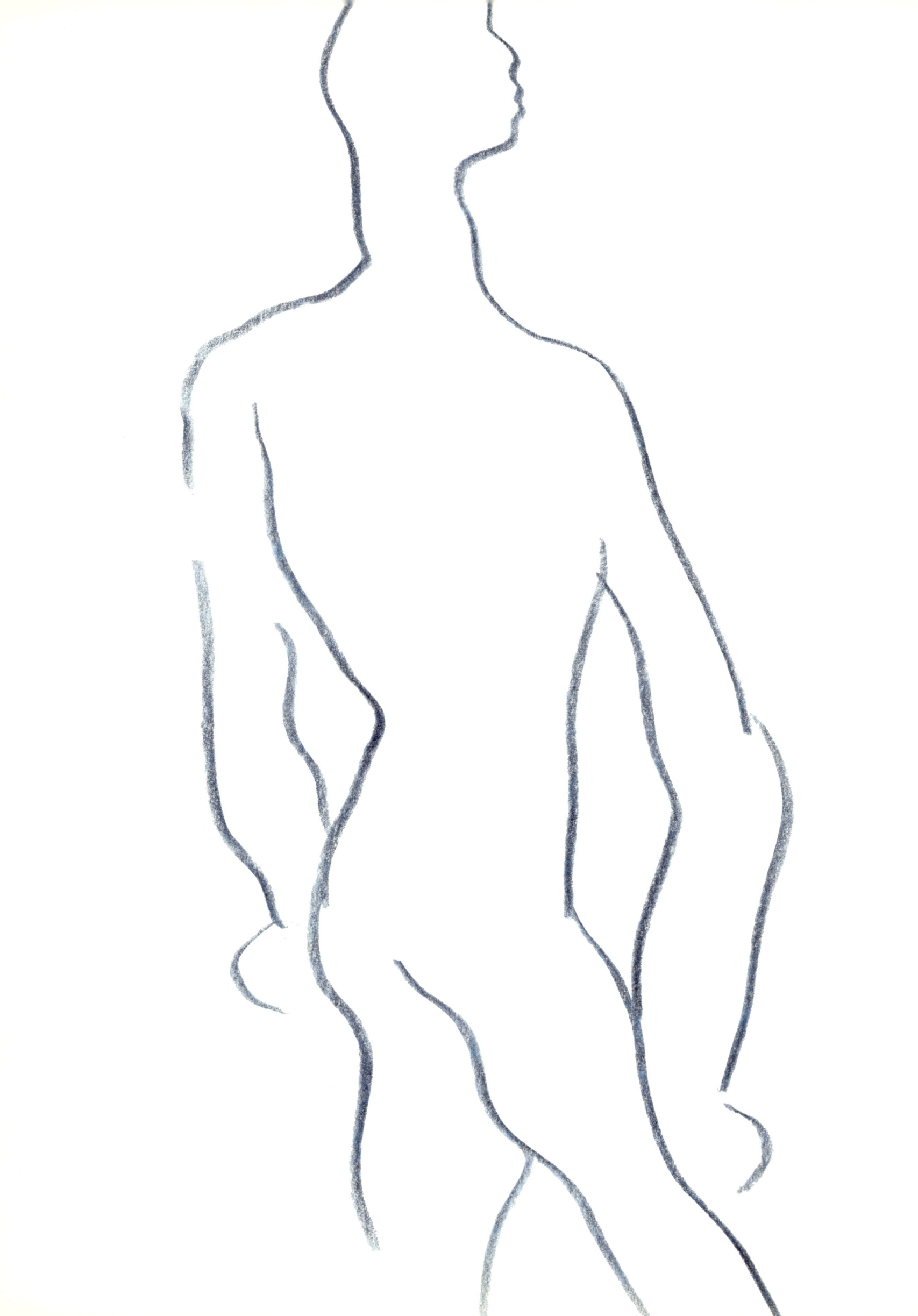

November 4th, 1945—a premature Scorpion birth…mother, Annabelle; father, Zack, Jr…Houston, Texas, and the Gulf shores…a near-fatal blood poisoning…a nickname—"Chuckie"…a lost sister and new brothers—Peter and George—"the boys"…the 50's and a yellow cowboy shirt…the premiere of *Giant*-Liz, Rock, Jimmy…a mother's detection of cancer…a move to Kerrville, Texas and the Hill Country…Jenny, Smokey, and Mittens…a mother's birthplace, a mother's death place…a father's departure…an "adoption"—Aunt Mae, Uncle Sha, "Em," a new home, and a bedroom as sanctuary…drawing, designing, dreaming…the beginning of the journey of a man, a Carr, a Texan, an American, an artist, a spirit…

Tivy High School—the early 60's…NYC, DC, the Kennedys, and a black lace mantilla…French kisses, French rolls, Kathleen, and Audrey…Pat Boone and Debussy…a sailor in *South Pacific* with Sue…Santa Fe, Mexico, and enchiladas…The University of Texas at Austin…the Flowering 60's…interior design and Frank Lloyd Wright…the Beatles, Mick and the Stones, Aretha, Roy, and Stephanie…water buffalo sandals, turtle necks, hippie beads, and black horn rimmed glasses…Europe, Paris—a YSL fashion show…*Vogue, WWD, Life,* and D.H. Lawrence…summer school in Italy and Modigliani…the journey continues with similar spirits…

New York City…the early 70's…B. Altman's, Richard, and 92 Grove Street, Sheridan Square, Greenwich Village…Parsons, Keagy, Rizzo, Essex, Brantley, the Golden Thimble Award, and a pea coat…Donald Brooks…Max's Kansas City, Andy, Joe D., *Flesh, Heat*, and the East Village…Betsey, Bunky, and Nini…Corky, Vickie, "Groovy"…Morocco, India, snakes, and elephants…Sylvia, Rive Gauche, and a St. Laurent safari jacket…the journey flourishes with a new personal power…

A call, an interview, a union…Calvin…Calvin Klein Collection…the mid 70's to the mid 80's…a decade-a history…Barry, Sheryl, Kelly, Susan, and white Brooks button-down shirts…John…Bruce, Nan, David, Sam…Bellport and South Howell's Point Road….Morocco, souks, and amber…Santorini…Japan…Santa Fe and a leaf from O'Keeffe…Mexico, Barragán, and Isabella…Frances…Marina, "Bambi," and "Birdie"…Liz and Grace…Raoul's, JS Vandam, Studio 54, Texarkana, fried chicken, and Lone Star beer…70 West 11th Street and Le Corbusier…No. 11 and *Suddenly Last Summer*…the journey finds love…

A new adventure…Zack Carr Collection…GFT, Milan, John, and Roberto…the mid 80's…Torino, Portofino, Nice, and Matisse…a first collection—camellia, Chanel, and Balenciaga…*WWD, The New York Times, People,* Saks, *The Today Show*, Bryant Gumbel, handshakes, and secrets…a new, vintage Porsche…Africa and Isak Dinesen…a closing…Kyoto…a return…NYC…the journey follows a personal dream and finds a higher faith…

A new opening…Calvin…Calvin Klein Collection…a return…the late 80's to the late 90's…the Brookhaven cottage , "Buster," the Bellport Kitchen, and 'ritas…a promotion…Calvin Klein, Inc…a teacher, a guide…Gwyneth, Carolyn, Matt, Jackie, Narciso, Sarah, Michael, Dean, Kathryn, Carol, Robert, Gianluigi …a new home—59 West 12th Street, No. 11C…Robert and Florent…Paris, Christmas, and Café Flore…Istanbul, the Bosphorous, and an afternoon Fanta…the journey embraces wisdom…

A change…an illness…Poem's Syndrome…the late 90's…Dr. Reich and Memorial Sloan-Kettering…the home as sanctuary again…the caretakers—Ouija, Linda, Kelly, Shontec, Paulina…Nancy, Kenneth, Balthazar, and champagne…Gregory, black cashmere sweaters, and the flowers…"Maximillian" and a last vacation to Maine…a Mont Blanc pen and Hermès "croquis" books…the sketches and sketches and sketches…December 21st, 2000—the sketches stop…a return to Texas and Saint Peters Church, a family's farewell, and a silent night…January 4th, 2001—Saint Thomas Church, a rememberance from Calvin, and one last Stand…one journey ends in peace and another begins…the spirit finds forever…

George Carr
Los Angeles, California, March 8, 2002

For New York City,

For my country,

for all,

my brother's art,

my brother's love...

George Carr

New York City, April 19, 2002

love vrothers

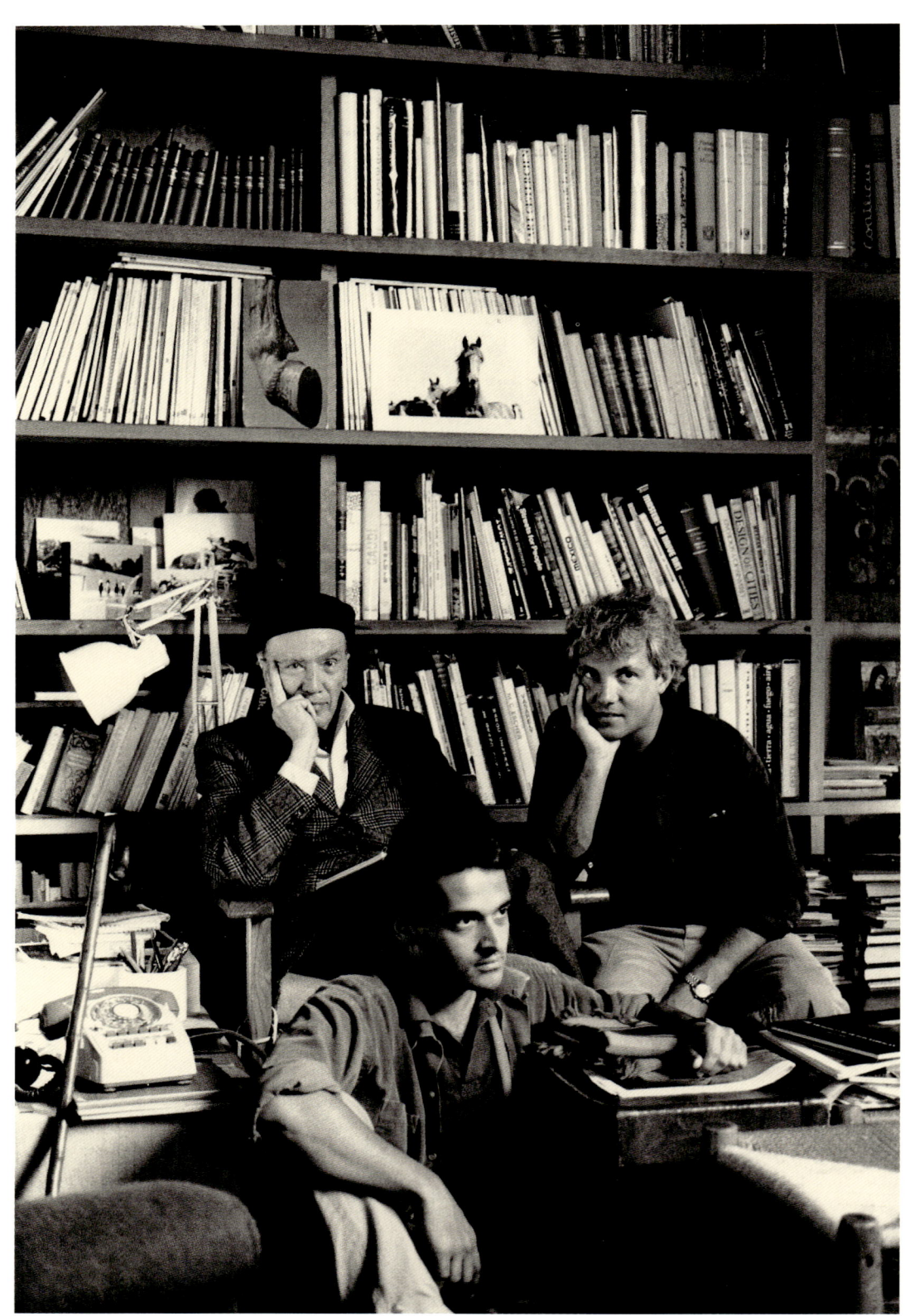

"The minute I met Zack I felt like I had known him a hundred years. He seemed to encompass everything—from your childhood to your teenage years and even your ideas about art and music and painting and philosophy. Zack was also inspirational in the way he related to people's sexuality. He made you look at the handsomeness of someone in a special way. Zack could at one moment be superficial and then turn very serious and then he'd get the two mixed up, which gave him a great sense of humor.

I'd heard about Zack from all sorts of people in the fashion industry, but the first time I met him was when I was working for Calvin Klein. I was in a studio with Frances Stein and I was getting ready to photograph a gentleman named Romeo. At this time, Calvin was doing these beautiful, simple, white linen shirts and I was going to photograph Romeo in the shirt and jeans. I remember Frances' assistant was crying while she was ironing the white shirt because she was having trouble getting the wrinkles out and we knew Calvin didn't want any wrinkles showing. And then Zack walked in. He was carrying a pair of jeans on a hanger, but the way he held them, you would have thought he was carrying the most beautiful couture dress stitched by fine seamstresses in France. Of course, Zack immediately started playing off the name 'Romeo,' saying, 'Romeo, Romeo, wherefore art thou Romeo?' As Zack helped dress Romeo in the jeans and white linen shirt, Romeo continued to eat his piece of pizza, managing to get bright red tomato stains over the front of it. Frances looked at Zack as if saying 'what am I going to do?' and then she turned to Romeo and said, 'we have one more white linen shirt and if you get another pizza stain on that shirt I am going to physically and personally throw you out of this 12th story window!' Romeo looked really frightened and then Zack looked at me, winked, and started to laugh and I knew exactly what he was thinking: let's photograph Romeo in that white linen shirt with all those pizza stains on it. The color would be fantastic and it would be a photograph to remember!

The first trip I took with Zack was to Mexico where we photographed Isabella Rossellini. Earlier on, it was Zack who had gotten me excited about truly looking at the early drawings that Georgia O'Keeffe had done, and now it was Zack who got us all excited about photographing architect Luis Barragán in Mexico City. We spent days pouring over photos and then discussing them at night. When Zack was dressing Isabella, I remember Mr. Barragán saying to him, 'I think you should let her be in bare feet' and Zack smiled and said 'Of course. That's it!' Zack was so open and he was open to change. Zack also had this real dark side to him, but he always explained that by saying 'I'm a Scorpio!' Even in that, Zack took pleasure. It's impossible to sum up Zack in one sentence, but I know that when I think of him, what I will always remember is that Zack always took such great pleasure in being who he was."

Bruce Weber, as interviewed by David Hutchings

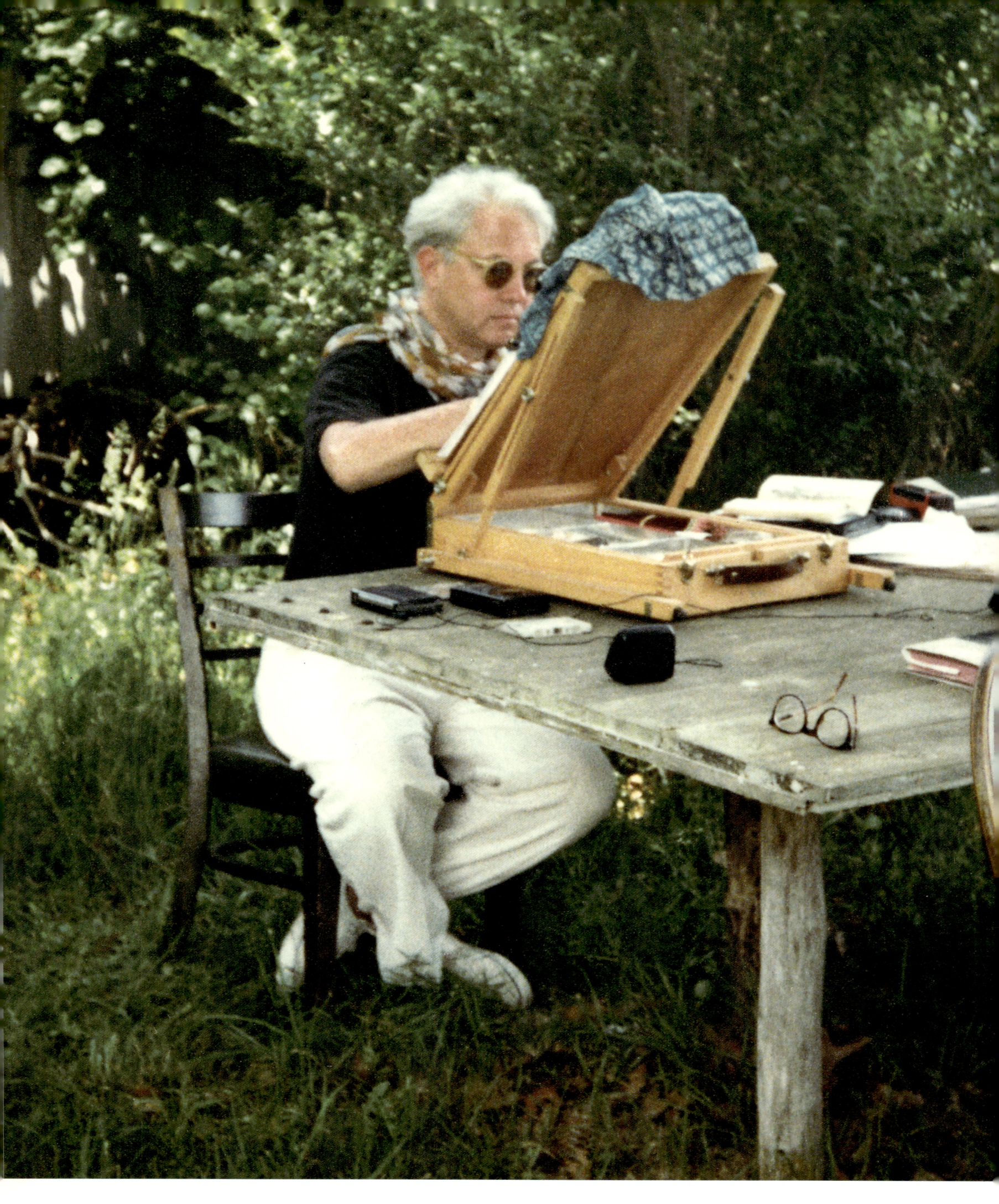

to be happy as a designer — to overcome all

my fear, fear of ridicule, fear of rejection

Dear Mae, May 24th, 1952

I am surely working hard with Chuckie with his reading, storytelling, and ABC's. We study when he comes home from school in the afternoon, at night, and a little while in the mornings before he goes to school. He is doing so much better and I can see that he is improving all the time. Today he is telling the story of "Sunny the Bunny." He wants to tell "Jack and the Bean Stalk." I have looked at several

stories here and also in the village, if you can find it buy it for me and send it to us, will you?...Thanks, too, for the flower card as I know Chuckie will enjoy the pretty card as he likes things like that...Chuckie and I stayed for church, from now on he and I are staying for church as he is old enough to go now... After Sunday School, Chuckie and I went to church, he wanted to go so I went with him. A picture here now, "The Life of Christ," I plan to go Friday night and take Pete & Chuckie especially Chuckie as he is interested in religious matters. Chuckie brought his report card home today. He made 3 B's and 1 C–a very good card, but tell Uncle Sha that he wasn't home to send his report card. However these last six weeks he plans to study hard and make one A.

But A's are hard to make as that is "excellent." But I want him to do his very best in school. Only six weeks more of school...Have been patching his blue jeans. I plan to buy him one more pair of khaki pants. I like khakis better than blue jeans...Today is May Day. First day of May. Chuckie made me a corsage out of flowers that he took to school this morning...Chuckie was all dressed up this morning in a yellow cowboy shirt and his new khakis. He was freshly bathed and hair washed and looked just like a school boy should. He was so thrilled yesterday over you sending him the packages. Especially the story book. Now, he plans to tell "Sleeping Beauty" at school this week. The book, too, has such nice selections of stories, he

won't have any trouble now finding stories to tell at school…As we were going past Pal School, Georgie said with much pride—there is Chuckie's first grade! My, you would think he is president of the U.S. the way they speak of him being in first grade…Chuckie has plenty of clothes now to last him till school is out, he did need another pair of long pants though, and I'm happy…Love, Bell

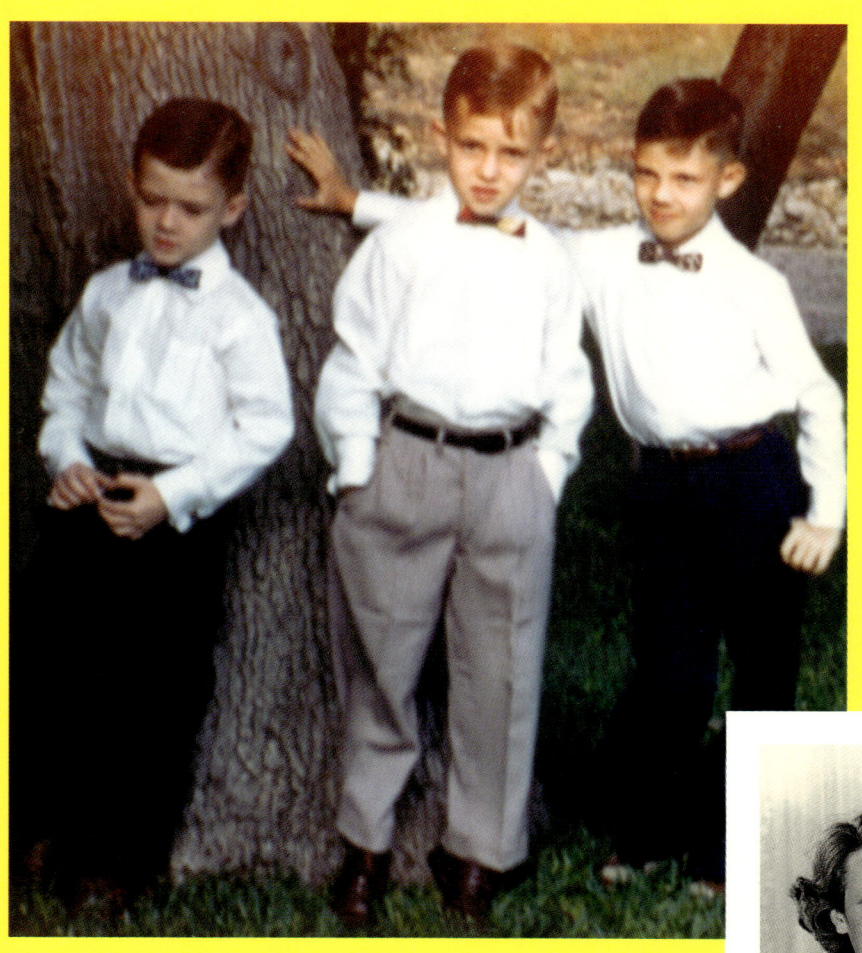
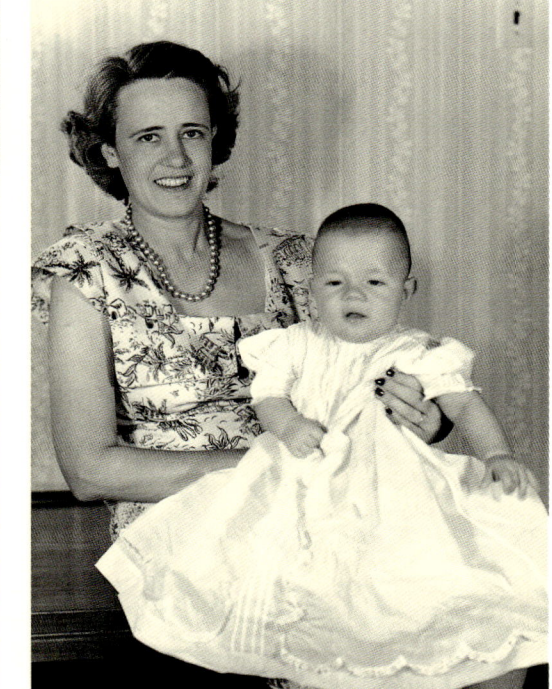
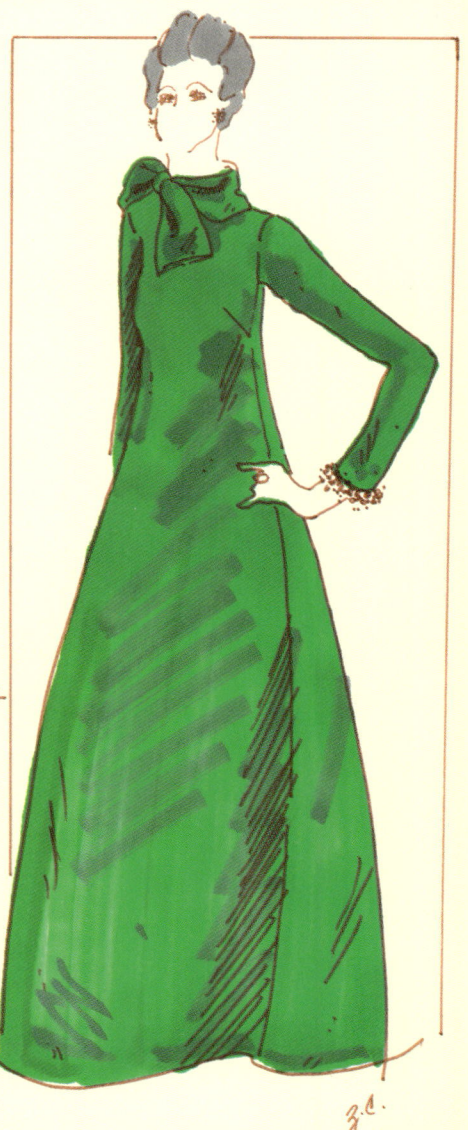

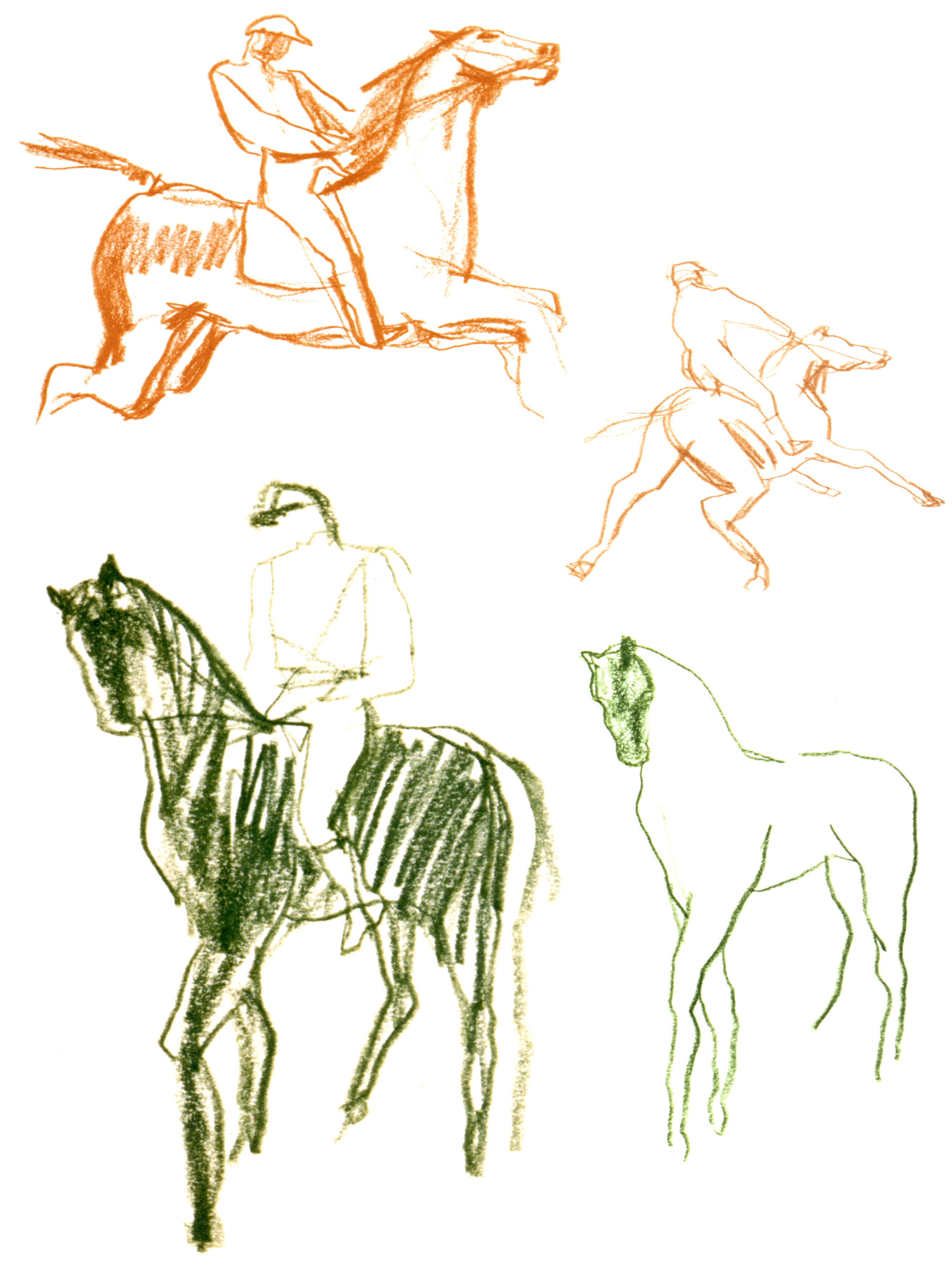

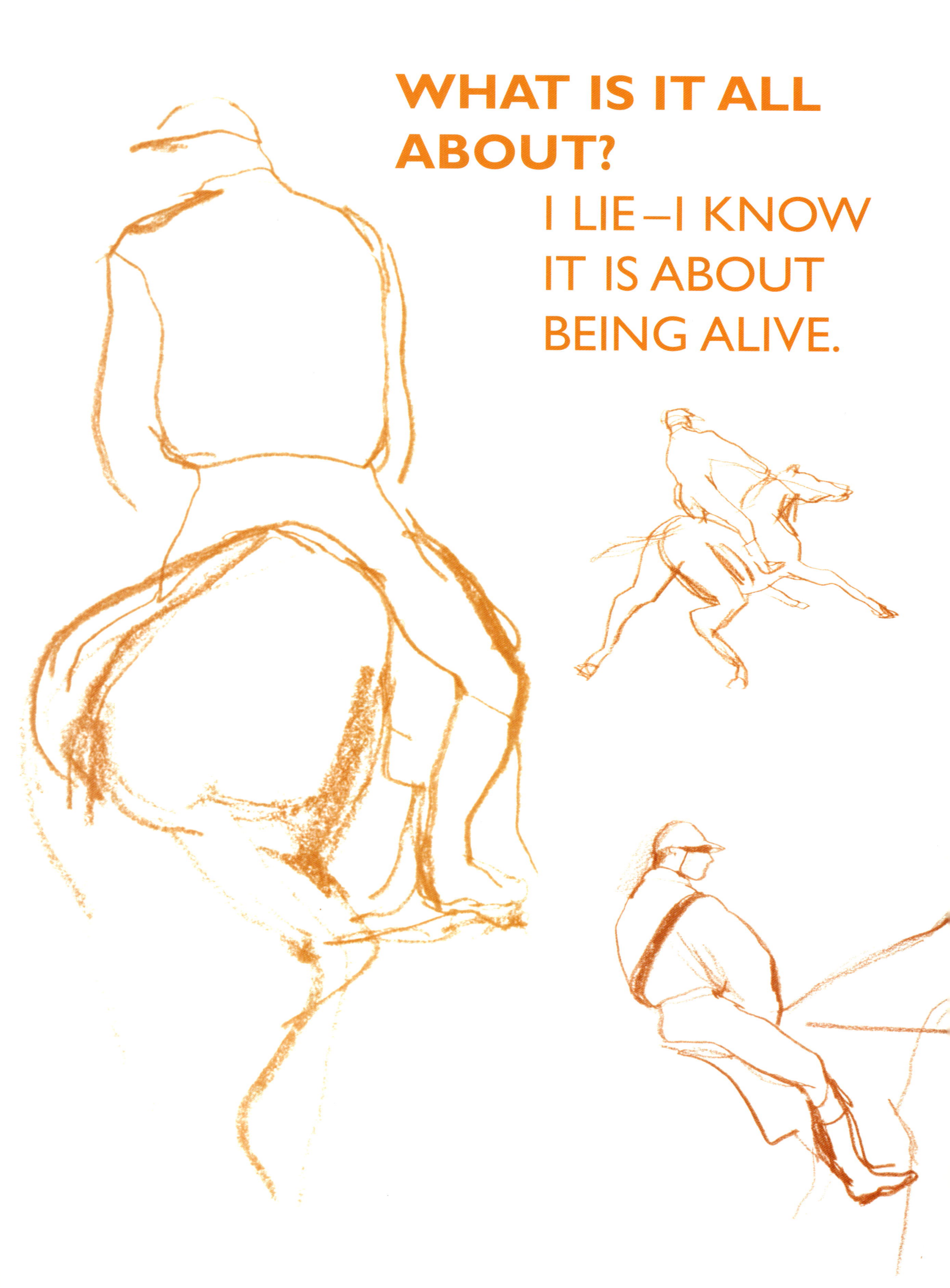

WHAT IS IT ALL ABOUT?

I LIE—I KNOW IT IS ABOUT BEING ALIVE.

I am going
to be given
pleasure!!
love
love
love

Paris, November 11, 1990

I can be an integrated person… the good and bad, child and adult—don't judge either—they are all meant to exist… I am a solid, good, ordinary person… believe me, I am.

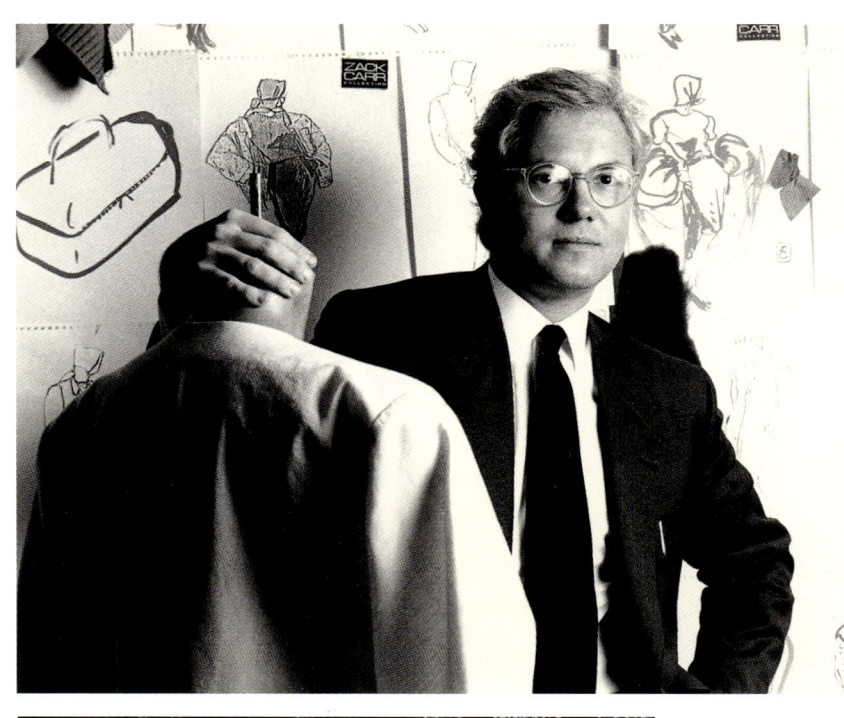

Stay with it, embrace yourself— give yourself your respect, your love, your light— sell that product… and let myself be cleansed.

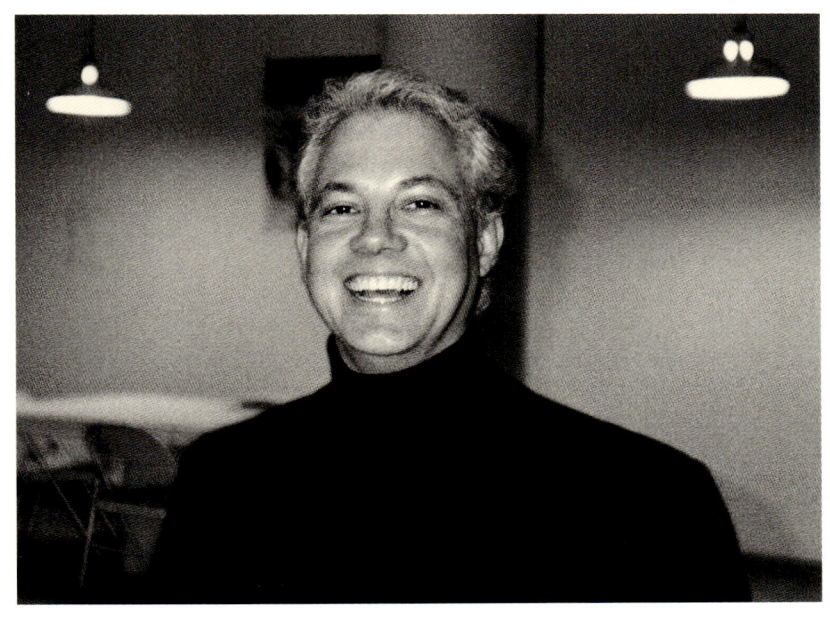

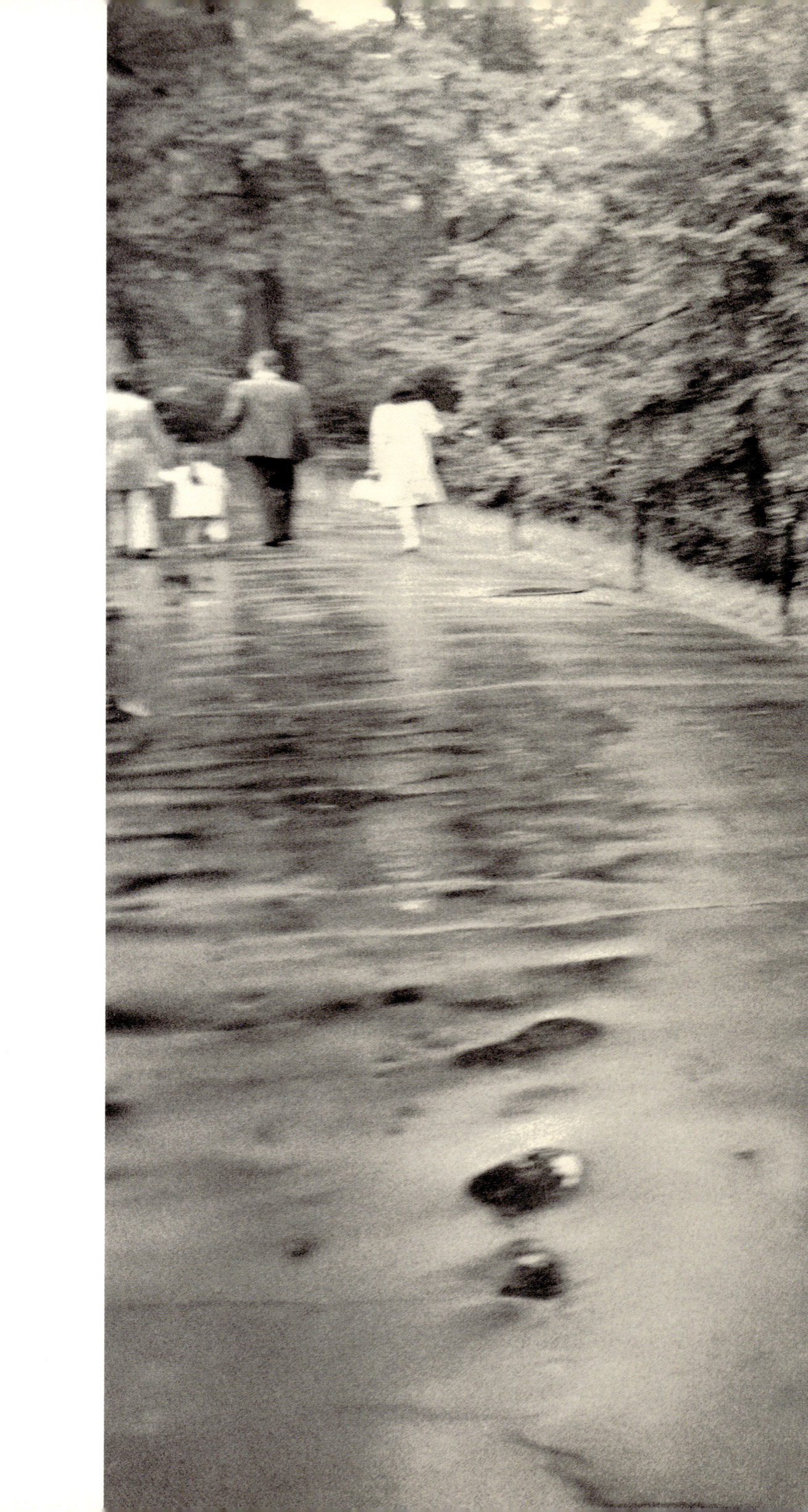

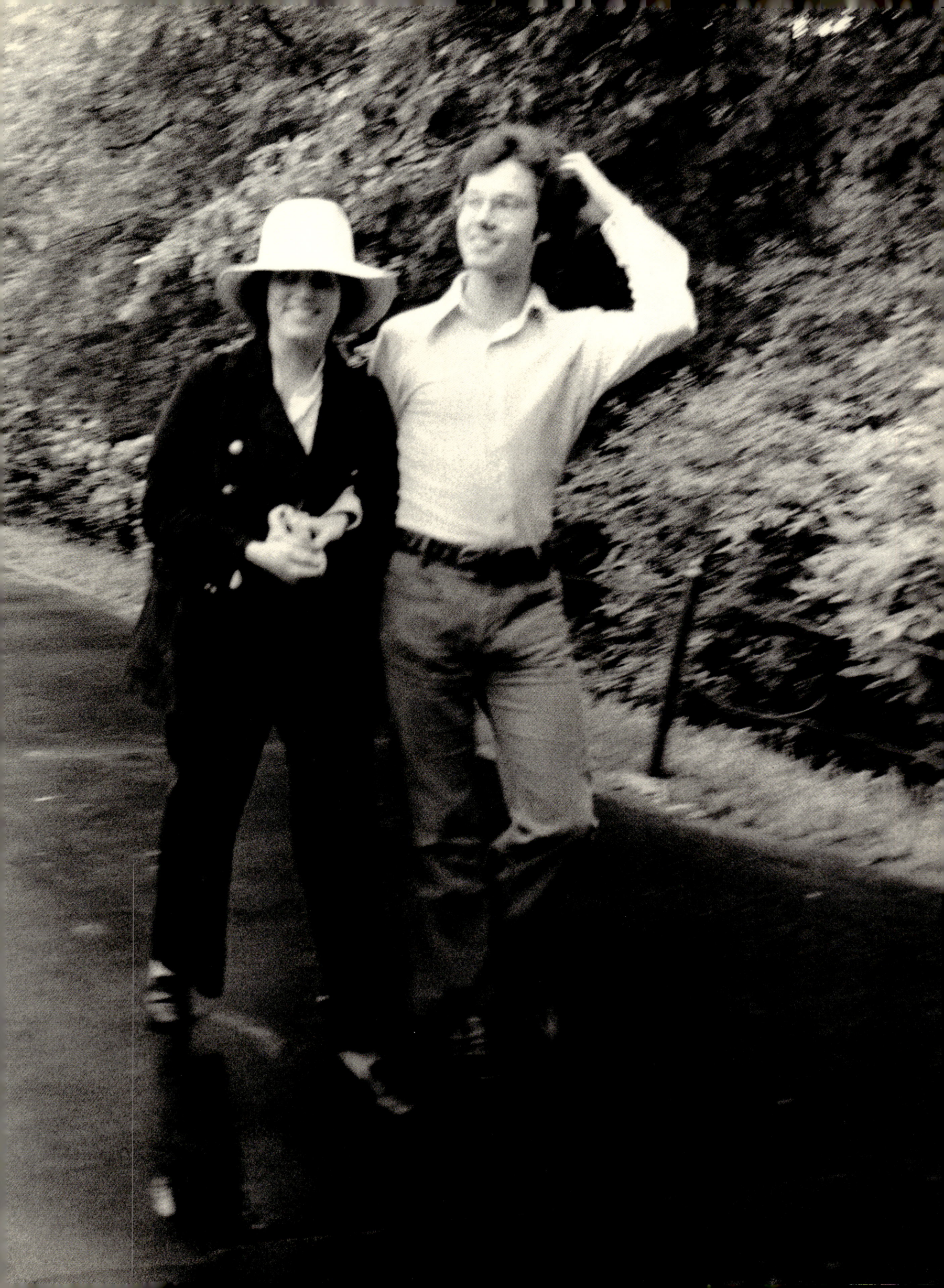

Now, and I can let
the healing…
　heal my fear of success,
fear of my fallibility—
　fear of my own light—
And let go of some major
　　portions of
either self-sabotage—

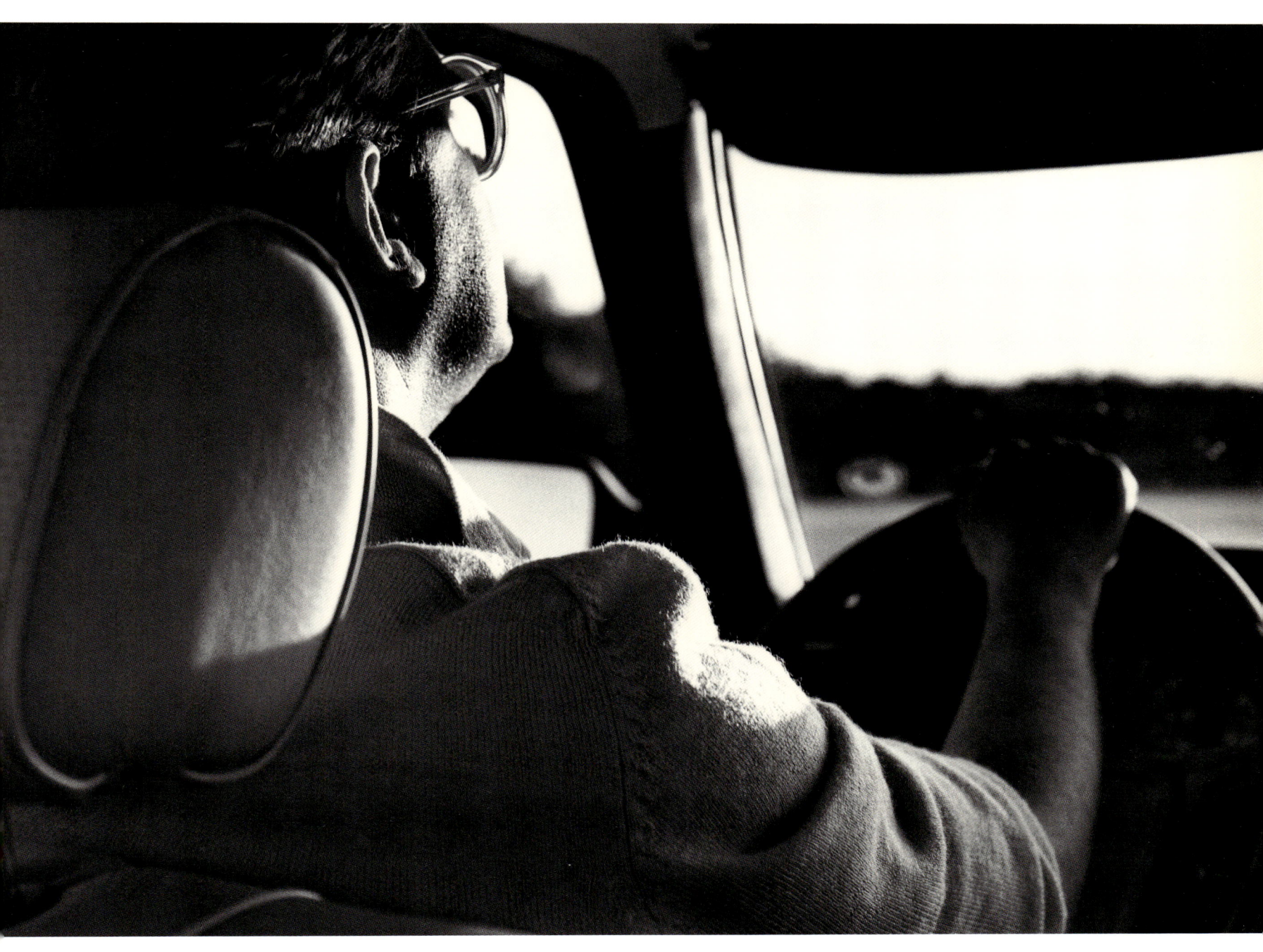

or self-intoxication!

Now, why don't I combine both worlds... Reality—the earth, the soil, the leaves, the grass, the streams, the flowers, the fruit, the harvest, the grain— with the spirit—also, all cultures— the Tartars, India, the Mongols, the Chinese, the Italian Renaissance, the Egyptians, the Africans, the French Cavaliers, the English gentleman— the American businessman...

Now, remember every thing that came before: Italian Renaissance, Leonardo da Vinci, Piero della Francesca, Botticelli, Tintoretto, Titian, Flemish, Vermeer, Dürer, Van Dyck—elegance, sophistication, sensuality, poetry, lyricism, fluid, delicacy— Renaissance page boys, Romeo & Juliet…

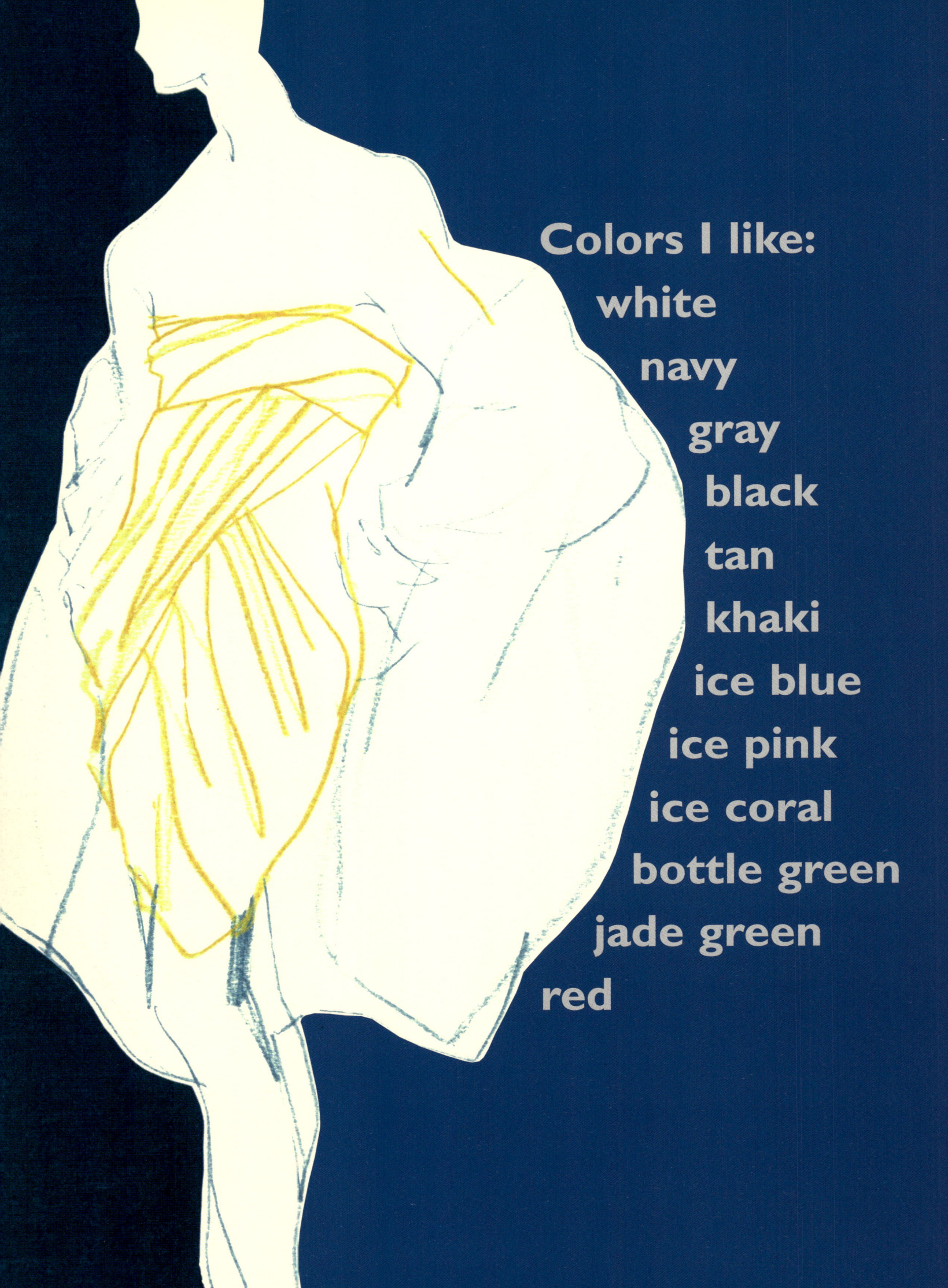

Colors I like:
white
navy
gray
black
tan
khaki
ice blue
ice pink
ice coral
bottle green
jade green
red

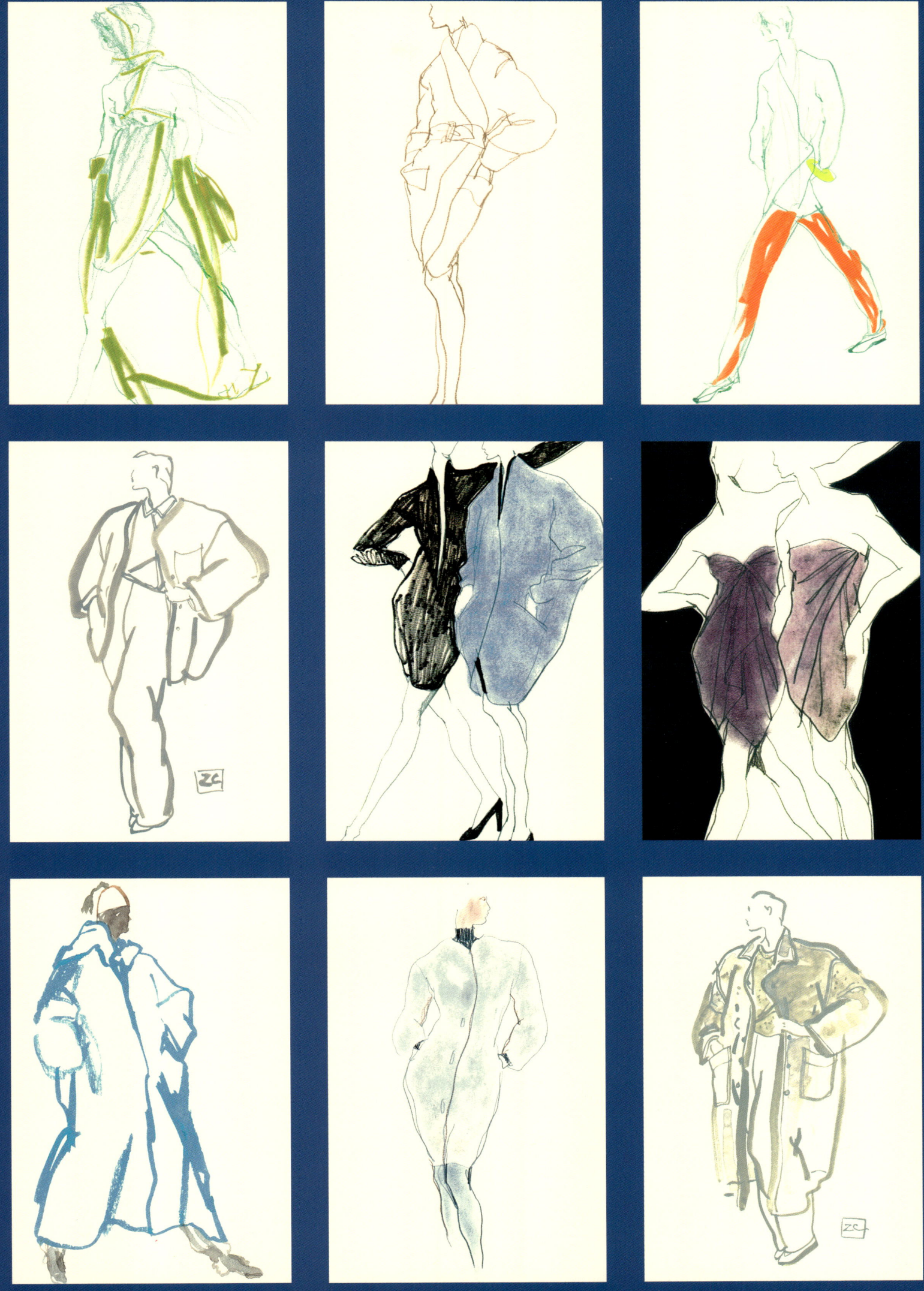

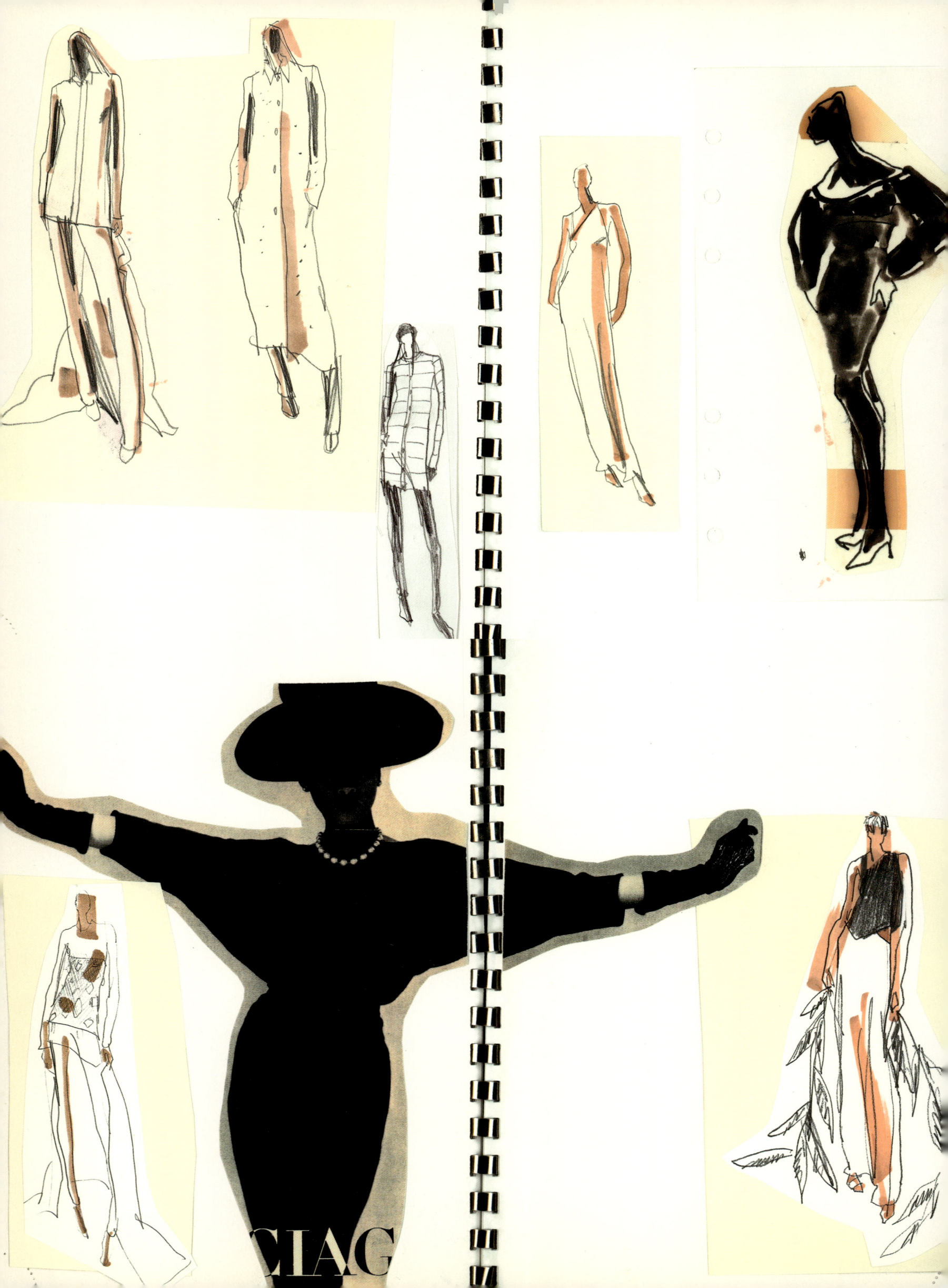

April 30, 1999

This is my collection—
For and by myself,
for no one else—
my favorite
thoughts and ideas—
loves—I love
these clothes—
Zack Carr Collection

I am the only one
 who can make my life work

New York
is not going to change
for Zack—
There are people
out there
and it is alive—
Stand up
and be counted!

My Girls

Audrey
Jean Shrimpton
Isabella Rossellini
Babe
Amanda
Lee
Jackie

Gloria V.
Mrs. C. Z. Guest
Grace Kelly
Gwyneth Paltrow
Tippi Hedren
Kim Novak
Vivian Leigh

Mrs. Rex Harrison
Frances
Gloria Guinness
Kelly Klein
Sheryl Schwartz
Mrs. Cushing
Georgia O'Keeffe

Patti Smith
Isadora Duncan
Jean Seberg
Romy Schneider
Pauline de Rothschild
My imaginary women
Evangeline Bruce

Anna Wintour
Marina Schiano
Kate Moss
Grace Coddington
Carolyn Bessette Kennedy
Nan Bush
Christina Ricci

olyn Bessette
nedy

My
heart
you
ask—
someday
when
you
hear
of
my
death
you
will
know
in an
explosion
of
ecstasy
that
I loved
you
dearly—

Touch me…

I AM **ROCKY** RAMBO OF FASHION

My Favorite Movies

Jules et Jim

If

Tom Jones

2001

Audrey Hepburn's Movies

Lawrence of Arabia

Cinema Paradiso

Blow Up

Cinderella

Hitchcock

Vertigo, The Birds, Rear Window

This day reminds me of days
 in Milan and Turin—
 so much rain,
 so gray,
and in my really young days
 I longed for these days—
the poetry of gray mist, yellow light,
 dying leaves—
 the melancholy—
 this loneliness,
 the isolation—
to wander through soggy
 woods and dream

Yeah!

exas

No more defenses—Get down and get nude

Chanel

Balenciaga

It has always been my desire to combine Chanel with Balenciaga, because I believe they were the two great movements in fashion— in present day psychology—right side and left side of the brain...

fluid–
architecture
feminine–
masculine
Chanel–
Balenciaga,
Chanel
the fluid,
sensuous line,
feminine–
Balenciaga,
architecture,
linear,
abstract,
geometric,
shape,
masculine

Audrey & GIVENCHY

I saw Audrey Hepburn's "Funny Face" one Monday afternoon immediately after junior high's last class. I stayed until the last movie of the day. Saw it almost three times—would have gone on forever wonderful, high, totally in love.

I would have liked to be Givenchy...

*When JFK and Jackie came along,
I first sensed Jackie as a Senator's wife—
in a beautiful white satin
strapless gown by Lavin-Castillo*

*She was radiant—apart, elegant, and like Audrey—
sublime, absolutely sublime, and I think you
should appear to be like these two women—
only to find out this perfection is rare and makes
for loneliness—distinctive but lonely...*

If I had a business, I would begin
again with my first collection—high Anglican taste

severe, sober, taste, elite

cashmeres from Colombo

sheers from Harare

satins from Bucol

wools from Tessile Club

knitwear by Ada—

tremendous amount of knitwear

fabrics from Braghenti, prints from Hurd, rayons from Pichot

Very elegant, like my memories of Bergdorf Goodman,

Jackie Onassis

Cushing sisters

Babe Paley

C. Z. Guest

Audrey Hepburn

Gloria Guinness

ZACK CARR
COLLECTION

a leaf.
from.
O'Keefe.

My
 sketchbooks
 "are what I consider
 a true expression of myself...
 my being...what interests me,
 what excites me, what
 is me...and is my
 true being."

I STILL THINK OF AFRICA — BRANCUSI — PRIMATIVE CYCLIDIC

GRACE REMINDED ME ABOUT SWIM WEAR — I'LL THINK COMME DES GARÇONS — DO LIKE IT ALL — TWIST UPON TWIST — AND SO GODDAMN "CHIC" —

APR. 24
SUN. — FLYING TO PARIS VIA GENEVA W/ GRACE … READ ABOUT BERTOLUCI'S "LAST EMPEROR" — SO GODDAMN EMPRESSIVE —

APR. 26 —
WE LEAVE PARIS
1) BRASSERIE BAZAR
2) BOFINGER
3) PA·10 PEVERSE AND LIFE
4) IRENE
5) DAVÉ
6) CAVIAR CASPIA
7) LE SOUFFLÉ

SENEGAL

GRACE —
FLIGHT TO PARIS
APR. 24, 1988

have completely given myself over to supporting Calvin

Encouragement and
the permission
 to strive
 to go on
 to shine
 to fly

Postcard 1 (top):

SSP 289 BAMBI & SKUNK

Dear Bambi,
Remember when we saw each other all the time?

Love,
Flower

Zack Carr
59 West 12 Street
Apt. 11c

Card 2 (bottom left):

Zack on your Birthday
A wish that you may
Penetrate the illusion
of no hindrance.

Best wishes
&
much love,

[signature]

Card 3 (bottom right):

23 December 1998

Dear Zack —
I do hope that 1999 is a much, much, much better year for you & that you are properly up & about and causing trouble at Calvins' again. We all miss you so
lots of love & affection
Grace

For Zack –
Happy Birthday
We all miss you
& send you our
love –
Bruce & Nan
& Rowdy

Zach —

Discover that which brings you happiness.

And indulge ! ? !

Happy Birthday !
Love, Dean

Zack

In celebration of life & your birthday... I wish you strength, courage & love

♡ your [?]

happy birthday to Uncle Zack...
love Jesse ♥

Be Happy, Happy, Happy on your Birthday!
Dearest Zack
Love always - Mel

MARK ROTHKO (1903-1970)
UNTITLED, 1969
ACRYLIC ON PAPER MOUNTED ON CANVAS
54 X 42¼ IN.

1998

Dear Zach,
Happy Birthday!
My dear friend
Wishing You All of
the Very Best...
So Much Love to You.

Michael Berkowitz

COLLECTION OF CHRISTOPHER ROTHKO
COPYRIGHT © 1998 BY CHRISTOPHER ROTHKO AND KATE ROTHKO PRIZEL. ESTATE NO. 2069.69
AP831 ARTPOST, BOX 661 CANAL STA., NY, NY 10013 ISBN 1-881270-62-9

THE "PERFECT" NEW EXPRESSION OF OUR TIME IS ARCHITECTURE

I am going to
love to
find the truth
day by day
one step at a time
I am going
to have to
work on I am depressed
my depression and afraid
and about
my truth each aspect
 but I've
 decided to
 accept
 my
 deepest
 loneliness

I need to work out some internal anger, fear, and confusion—which, when all is said and done, is going to come to this point—I am going to have to come out as I am—as Zack Carr—with this body, with this mind, heart, and soul, and this head of hair—just as I am. No fantasies, no outdated, long-desired options, and <u>no</u> other history except the truth.

Why? So that I could have a healthy, joyous love towards my heart—instead of hiding from others and from myself—"only on the sly" kind of mental respect, keeping it repressed, keeping it internalized—the desire for seeing it made real as I had done with my Mother—I wanted her to continue to make up my sketches into reality—to see the whole—then to see them go from dolls to human beings—then into a business, and for my own recognition and applause, which in my innocence of the times only <u>seemed</u> correct—not narcissism or mega

egomaniacal—just respectful in accordance with my will and expression of my talent—very simple, really.

This isolation is <u>not</u> good for me. I need to at least work with it—is it a part of my life so I can become more spiritual. It is obvious to me that unless someone walks into my life in a big way and makes a big impact—starts me going in another direction, it will continue. The apartment is almost completely deserted, and I am pleased, I use each room now as never before—and it is integrated—more sophisticated—I've left my mark upon it—even the closets are better arranged. And my wardrobe is complete and sumptuous even. And it will be paid for and even my Visa card will be paid out by Christmas—also Barneys—So, what's left—Trust. To have trust in God—his all-caring love, even when I do not understand or agree. So, I should be able to let go—and internally be less and less afraid. Why not?

TO MY ADORABLE ZACK

LOVE BIRDY

Dear Zack,
...Be well and creative
 as I know you can be.
We need you so much to
contribute to American Fashion.
 Blessings.
 Love,
 Polly

Dear Zack,
If there is a soul beneath all
 those dark clothes—
 then surely you touch it...
 Ily
 A. XOX

Stand

A poem for us

I stood with him on the Gulf shores

 and became alive.

I stood with him on the Hills of Central Texas

 and saw the future.

I stood with him in the center of the world in New York City

 and became a man.

I stood with him on the banks of the Seine and the Bosphorous

 and learned the secrets of life.

I stood with him at his deathbed

 and learned the secrets of eternity.

I do not stand alone today

 For I stand together with you

 and with my brother Zack.

When you stand with Zack, you stand taller, stronger, brighter,

And I am filled with his love, his goodness, and most of all,

 the memories.

I remember the touch of his hand and his talents,

 The sound of his laugh and his hope.

I remember the taste of his food and his generosity,

 The smell of his candles and his strength.

I remember the light of his eyes and his visions.

Let us stand—together with Zack,

And in silence remember each of our special

 memories of Zack.

For Mother, Father, Aunt Mae, Uncle Sha, and Peter

 and all of his family

 who stand as his angels,

For Rev. Krauss and all of Saint Thomas and Rev. Kelly

 and all of Saint Peter's

 who stand as his guides,

For Dr. Reich, Dr. O'Sullivan, and all his doctors

 and nurses

 who stand as his healers,

For Shantec, Linda Kelly, Ouija, Paulina,

 and all his caretakers

 who stand as his protectors,

For Grace, Nancy, Kelly, Marina, Sarah, Nan, Katherine,

 Melanie, Isabella, and Gwyneth

 who stand as his muses,

For Dean, Matt, Michael, Gianluigi, David, Gregory, Robert,

 Bruce, Didier, Richard, and Sam

 who stand as his friends,

For Barry, Sheryl, and everyone at Calvin Klein

 who stand as a family,

For Calvin who stands as a brother,

For John who stands as a true friend,

 and for all of us today;

We are not alone, for he is with us forever.

And yet we add one more memory,

Another memory to brighten our way,

The memory of all of us here

standing with our beautiful,

beautiful Zack.

George Carr
December 24, 2000, Kerrville, Texas
January 4, 2001, New York City

I will not go on until I believe in myself. Have no fear, love God and love myself

I enjoy so much writing about Zack. It is a way to be near him. I imagine him smiling at my story. I do hope so. I would not see Zack for years and when we'd get together we'd start the conversation where we left it. Mostly, we talked about love: love's joys, love's aches, love's troubles and love's desires. Zack was a romantic. He lived my love stories with such participation that he made me feel like I was "theater," not just a woman. Because of this I could tell Zack all. He never judged me. At the most "sinful" twist of my love adventures he reacted like a spectator does to the best, most thrilling scenes in a play. This peculiar participation made me feel redeemed. There was not a person on this Earth I felt like talking to about what was most secret to me more than Zack. His reaction made me perceive an event I was ashamed of as comical. He made me look at an insecurity of mine as vulnerability; something cruel I had done became, in his interpretation, a decisive, strong womanly move. Nothing I did perturbed Zack. He was sensitive, vulnerable, nonjudgmental, loyal, and also infinitely curious, a curiosity that revealed vivacious intelligence and his thirst for knowledge. He would travel long distances to be inspired for his fashion designs. He came back with presents (he was very, very generous), stories, and enthusiasm for everything he saw, every person he met. I owe Zack not only his friendship (many laughs, wonderful dinners) but, most importantly, I owe him the birth of my daughter Elettra. It was Zack who organized for me to meet Jonathan, it was Zack who prayed to whatever God that we would become lovers, and it was Zack that wished for the fantastic "coup" in the theater of my life. He wished me to become pregnant by Jonathan while I was still married to Martin, and that's what happened. While the rest of our family, friends, and acquaintances screamed in horror, Zack glowed in total delight. *Isabella Rossellini*...........Dear Zack, En route to Paris, I'm thinking... you do know this is for all of us who dream and die a little in the light; happy to give and receive, not a little, maybe too much, never enough. I miss you. I love you. I thank you. *John, p.s. I enjoyed driving for about a year, or so, but, now, I don't really give a damn!*............For many years Zack Carr was inextricable in my mind from Calvin Klein. This gentle, industrious, and brilliantly creative man never searched for the limelight; Zack had no ego, and for this reason always struck me as most un-fashiony. But as Calvin's right hand—and right eye—he came to enjoy the admiration and affection of so many. He was a reluctant star and is dearly missed. *Anna Wintour*............ Zack's imagination always inspired me. *Kelly Klein*..............When I think of Zack, I think of Christmas and the anticipation of receiving his incredible gifts—always a wonderful sketch of something near and dear to Barry and me—the horses done in a "Degas" sort of way. We treasure them. Zack was the "other" Jewish mother when our daughter Stephanie was getting married. He went to all her fittings, went to Preston Bailey, the famous florist who designed the look for the wedding, and he even went to Chicago to fit the groom's grandmother and mother since they were afraid to fly. He directed hair and makeup for everyone in the bridal party and beamed like a proud papa when Stephanie walked down the aisle. It was the last time he really could walk. She got married on November 8—that Christmas he was in the hospital. *Sheryl Schwartz*...........Zack was one of the most original people I've ever known. Whatever he touched turned into something stylish, whether it was a bolt of flax linen or a dinner of Chinese take-out served on a slab of ebony or the early apartment he rented on 11th Street, which might have seemed a little unpromising to a less exacting eye. It had almost no light and its rooms were small and awkwardly shaped. But Zack gave the place a magical rose glow that made you feel like you were dropping by Georgia O'Keeffe's adobe ghost ranch in New Mexico. Soon after, he bought an ordinary house on an unspectacular block in Bellport and with just a few buckets of paint, several rugs and blankets, some sleigh beds and vases of old-fashioned garden roses and turned it into something unforgettable. My favorite of all was the apartment he later had on 12th Street whose walls were crammed with photographs of a lifestyle we all craved. There was a wrap-around garden terrace which always seemed to be full of white flowers climbing over arches

that would have made even Cecil Beaton envious. Even sickness couldn't cramp Zack's style. Later, when it came time to have a hospital bed moved in, it somehow took on the sleek shape of some exquisite piece of furniture from the Bauhaus. There, he sat covered with Hermes cashmere blankets in shades of grey, the same color as his sweaters and his soft, silver-grey hair. All my cats also adored him. When he came to visit us in Long Island, he would spend hours in my garden with Baby on his lap. She, too, is grey. They looked so perfect together, one purring, the other painting. *Grace Coddington*............Thank you so very much for the sketches from Zack. He was a wonderful man and always so supportive and loving towards me. I was so sorry to hear that he had passed away. I feel honored to have something of his. *Gwyneth Paltrow*..............I remember so many nights at three or four in the morning, Zack passionately arguing about the cut of a skirt, the way a collar fell, the stitching on a button hole, the perfect proportion of a Balenciaga jacket made for Givenchy with Bruce, John, Grace or anyone or no one....Zack truly loved fashion and life. Every moment was so intense...the laughter, the tears, the loves, the hates. Zack dared to dream. For the time spent, and time not spent, he will always be a part of my life. *Nan Bush*............Fashion, like every profession, has its unsung heroes: men and women who create, inspire, and generally make the world a better place even if most people have never heard of them. Zack Carr was one of those heroes. As the ultimate insider, he had an incredible breadth of knowledge and history, which was reflected in the magnificent drawings he effortlessly produced on a daily basis. His work at Calvin Klein influenced a generation of designers and helped give American fashion the importance it now has. And he always conducted himself like the Southern gentleman he was - with charm, wit, and an amazing generosity. *Patrick McCarthy*..............Dear Bambi, Your face looked so heavenly healthy, you were so handsome and happy when we visited you at your apartment one afternoon with my dog Moo-Moo. You were lying in bed, dressed impeccably white. The gold sunlight coming through the window made your rigorously decorated bedroom look, in a strange way, sharply black and white. I sat in a corner and I watched Moo-Moo's first encounter with you. Moo-Moo, a small black and white Jack Russell, was nine months old back then and fit perfectly in the environment. In a matter of a second, she was up on your bed with her tail moving frantically, started to kiss you everywhere and for the next fifteen minutes I could not stop her going up and down your bed with more and more kisses. She was hoping that you could get out of your bed, all of a sudden, and stand up and play with her. With us. *Thumper*...........Zack was the kind of guy who only saw the positive and was so full of joy and passion. I was lucky to have known him and see him grow. There aren't that many people on 7th Avenue that I love bumping into and getting into an endless dialogue, but I always wished there was more time with Zack. *Donna Karan*............A Remembrance: As I begin my research for my first trip to Japan, Zack is constantly on my mind. Not because of his amazing collection of kimonos or the boxes of silk skeins in every color imaginable—what resonates the most are his stories of the place. Zack had the ability to take everything in; visually, emotionally, viscerally really, then through his vast imagination, he created a poetic world, exciting and inspiring those around him. He loved to recount his adventures quite dramatically and in great detail almost as much as he loved to travel. I had the pleasure of travelling to Europe with Zack when we first began designing the Home collection in 1994. We took a day trip to Bath in search of antique textiles. On the train, Zack told me stories of his days in India as a young man; his description of the Taj Mahal appearing out of the morning mist was something to experience. It was an unusually brilliant day in England when we arrived at the antique dealer's house. The first thing that we saw was a bright green rolling lawn with freshly laundered linens laid out to dry in the sun; Zack was in his element. He naturally charmed our host with his enthusiasm, humor, and graciousness. It was Zack at his best. We were surrounded by piles of 18th and 19th century hemps and linens of every weight, texture, and subtle faded color. After making

quite a large purchase (Zack believed in beginning a project with abundance), we went to have lunch in the garden of the Royal Crescent. Everything seemed magical. I realized later that it was mostly Zack's vitality and shared perceptions which had made it so extraordinary. To me, Zack was, above all else, a gifted teacher who gave willingly of his time and spirit to share his unique vision. I miss him. During one of my first days working at Calvin Klein with Zack, he told me, "Designing for Calvin Klein is like preparing a fine costume; one must keep reducing it until it is finally at its essence." *Pamela Schumacher*...........I first met Zack in the very early days at Calvin Klein, where he was very much a part of that brilliant new design studio. Calvin and his team did all the clothes for me for two films. I got to see Zack's immense talent at work over and over again. I think that he had a big part in the creation of the look that is "Calvin Klein"—the elegance, the color sense, the timelessness, the modernity. But what I think of above all, when I think of my friend Zack, is the quality of human being he was: tremendously talented, of course, but kind and funny and decent and humble. He was a shining star in a particular world that so often produces ego and competitiveness before humanity. *Ali MacGraw*............I remember covering for *The New York Times* the collection he made in Europe which was wonderfully contemporary, maybe a bit too advanced for the times. But I also remember him as Calvin's calm (well, calmish) aide who did his best to make the hectic business of fashion comprehensible. He helped show me through the enormous collection Calvin showed at the Hollywood Bowl and helped make it understandable and relatively easy to cover. We all miss him too. *Bernadine Morris*............Zack and I attended Parsons at the same time. He was the "star" student with his impeccable taste, brilliant designs, gorgeous illustrations, and gentlemanly manner. I was the outlaw. But somewhere, we loved each other and through the years stayed connected. On one occasion when we ran into each other, he invited me to dinner at his place. He dazzled me with Moroccan food and auspicious predictions about my career. He said that what I needed to do was open my own store. I needed to showcase my world and what it was about. Well, that was the smartest business advice I ever received. I found a space the next day in Soho and developed my signature look while decorating the shop. Not only did that solidify my image to the clothing, but it also helped to attract all my licenses. In fact, my signature fragrance "Anna Sui" and my cosmetics packaging are all inspired by the "world" I created with my shop. *Anna Sui*............Zack and I shared not only a friendship that dated back to the 70's but also collaborated on one of my favorite fashion stories. I had been a freelance stylist working for *GQ* in the late 70's on a story with Bruce Weber. We were going to Hawaii with the models Jeff Aquilon and Andie Macdowell. At the time, *GQ* was just beginning to use women in their fashion spreads. It was still a time in fashion when one could be creative and not forced to use specific advertisers' designs. Because I was given free reign to use any women's designer I felt would be the most creatively suited for the story, I asked my friend Zack. One of our favorite movies was *Suddenly Last Summer* starring Elizabeth Taylor and Monty Clift. Somehow the mood of the story sparked the birth of Zack's #11 designs. The clothes he designed were all black and white in the most beautiful linens and crepes and extremely sensuous in their simplicity. We worked for weeks and weeks to get everything perfect but, most importantly, we had so much fun dreaming about the possibilities of the pictures. It was such an exciting and innocent time and the photos Bruce did are still among my favorites. But in my heart I know it was Zack's hand that made the story so special. *Barbara Dente*............ No question about it, Zack always impressed and inspired me and he still does. His talent to create understated elegance was unique. His style of entertaining was a mastery of restrained beauty. Above all his support for all his dear brothers, friends, and associates was limitless with his understanding of the most subtle emotions. He desired for all of us: elegance, excitement and love. He used to say, "If only I could offer the dress, or the trip, or the date this friend or associate longs for..." *Gianluigi Tacchi*............Zack was a wonderful gentle person who could identify the

best characteristics in people and inspire them to grow. His charisma attracted everyone he came in contact with and his ability to relate his experiences through stories mesmerized us completely. My favorite memories are when I designed for Calvin Klein Men's Collection in the early 90's. Zack was involved with our fashion show preparation and we would work the looks in the 11th floor women's collection showroom. Zack would enter the showroom everyday wearing a dark suit with a white shirt carrying his sketchbook and his fountain pen. He reminded me of a perfect mannered Southern minister carrying his beloved prayer book. He spoke the English language beautifully and still pronounced his "wh's" for white, while and when—which was amazing to me since he had lived in New York for so many years. His language and manners remained pure. When Zack spoke, he would carry me off to a dreamland which was like watching a beautiful film. I never wanted the stories to end because it was such a happy experience. Everyday when I look at Zack's last Christmas card on my wall, I go into that wonderful dreamland and bring back snapshots of working on fashion shows. When Calvin would take a phone call or step out of the room, the rest of us would join Carolyn, Narciso, and Anthony, who were gathered around Zack like eager students listening to anecdotes. Everyone would chime in with his own sense of humor. God, I loved and admired them all and I'm so thankful for the memories. *Pam Roberts Alvich, Calvin Klein, Inc.*............ In my experience in this industry, Zack possessed a completely unique combination of wisdom and taste. He had the ability to guide the design process in a way that fulfilled both the commercial and fashion needs of an apparel company and he did so without offending anyone. His professional skills were surpassed only by his fine qualities as a human being. I miss him and will always miss him. *Tom Murry, President and CEO, Calvin Klein, Inc.*............About Zack....I had the privilege of spending the last two years of Zack's life with him as his assistant. In truth, our relationship was on a much higher and more personal level than I have ever had with anyone. Zack was extremely intelligent, curious about everything (and everyone), and possessed an incredible sensitivity. Our conversations were not about fashion, they were about life and intellect. He had an amazing mind and a tremendously strong will. Zack was determined to be productive even when it was physically painful for him to do so. He would not be deterred from his beloved drawing until almost the end. Our goal was that he live as big a life as he could, given his physical limitations, and nothing delighted him more than to get dressed up in all his Prada and go with Kenneth Paul Block and me to Balthazar or Bouley Bakery where he would sip martinis in his wheelchair. Oh, how regal and civilized he was. Just to be with him made me feel as though I was in a different time and place. He had style, he had grace...he was my beloved Prince Charming. I can never forget the mellow sound of his voice, his wicked little laugh, and the twinkle in his eye when I told him he was being "feisty." Zack died as he lived...dignified, surrounded by things he loved, and people who loved him. He was prepared. He may not have been able to achieve all that he had hoped, but I know he will look upon this tribute to his immense talent with pride. *Nancy Glazer*............Zack Carr and I spent our first year at Parsons School of Design in 1971-1972. I remember the first time I met Zack. We were in a fashion illustration class in a stark white room with ten fellow classmates at the old school location in Manhattan in the East Fifties. We were both sketching a live model and he turned to look at me and talk, while sketching at the same time. I was awestruck that he could sketch and not even look at what he was doing. He had a rare ability to articulate a vision by looking for a brief moment and then quickly sketching it without having to even look at what he was putting down on paper. I was amazed at Zack's ability to sketch anything and his command of line was like liquid! We introduced ourselves and had an instant rapport that went on for over 25 years. We were both born around San Antonio, Texas, and shared many parallel visions and conceptual ideals that were a foundation for an intense relationship. Zack referenced the Texas Hill Country's palette colors of limestone white-beige, yellow ochre, cerulean blue, midnight

prussian blue, sage green, cedar green, and the celadon green of the clear Guadalupe and Medina rivers into a fashion standard in the years that would follow. In the spring of 1971, the first year fashion class was asked to create a fashion show, Zack asked me to be his model wearing a yellow ochre colored hot pant-suit that was designed with straps bearing the upper body. I was quite honored for him to have selected me but will never forget how nervous I was to walk down that runway at The Plaza Hotel. Hot pants were the rage for women, but hot pants for men was a gender leap! *Zachary Selig*..........Zack was both a friend and a mentor. He gave me boundless encouragement and guidance in the most dignified manner. For this, I will be always be so grateful. Design was Zack's world, it was his life. Zack could talk about design, art, music, literature, and what inspired him but he was never nostalgic; his vision was totally modern. His references were the spark that ignited his creativity. His muses were the paradigm of the woman or man that he aspired to dress or the room that he would want to design. He was so full of life, creativity, intelligence, and a wonderful sense of humor. Zack will always be missed but his spirit lives on in those of us who were fortunate enough to know him. *Michael Berkowitz*..........Whenever I came into Calvin's showroom for anything, Zack was always such a Southern gentleman. He would often beam when a dress suited me and say how beautiful he thought I looked in it, often times blushing. That's when I knew he was being genuine and I took it as the ultimate compliment. *Christy Turlington*..........My fondest memories of Zack are with Kelly Klein. You know, initially Kelly was Kelly Rector and she was in the studio as a design assistant with Zack and the whole gang. She is this great beauty and had that all American point of view in terms of fashion and lifestyle. She was also Calvin's girlfriend and they were living together at the time before they married. Someone a little less secure than Zack could have been threatened by the situation but instead he and Kelly became fast friends, collaborators, and colleagues. Calvin loves doing the collection more than anything else the company makes and he is always in the middle of the design process. So here you have Calvin, Zack, and Kelly, friends and associates, cranking out these amazing clothes for quite a few seasons. Ask anybody. This was the moment when the Calvin Klein collection became the most highly respected line of ready to wear in America enjoying rave reviews and eclipsing the competition in sales volume. And Zack was the galvanizing force. *Paul Wilmot*..........Zack took me to places I'd never been before, and he was a guide who had rarified tastes. While other tourists watched the snake charmers in the ancient souk in Fez, Zack took me through a serpentine maze of passageways so that we could watch some local women making this dazzlingly rich indigo blue dye. At one of his favorite stalls, he bought vials of amber and orange blossom water which he lightly sprinkled on his sheets back at the hotel. But you didn't have to travel to faraway locations to take a trip with Zack. Just listening to the ruminations of his mind was a journey unto itself. Through Zack, I experienced a small town Texas childhood, the death of a beloved, and far too youthful mother, and the transformation of a khaki-clad kid into a designer of innovative grace. It's been almost twenty years since I visited Morocco with Zack, but I still have that vial filled with amber. It's still both delicate and potent, like the memory it will always evoke of you, dear Zacky Carr. *David Hutchings*..........Zack inspired and taught. Zack talked and listened. Zack shared personal stories. And new ideas. And imagination and energy. Zack loved and was loved. I am privileged to be one of so many touched by Zack. *Barbara Deichman*..........Zack and I shared many happy and productive times at CK. We had a mutual respect for each other's work and learned a lot from one another as well. My most memorable time spent with him was prior to a new collection as it was being created, beginning with the fabric color selection. Zack would love to "merchandise" the collection with me as he would share the direction of the fabrics and colors encouraging my feedback and suggestions based upon past history and what was happening currently at retail. Eventually, we would move on to the silhouettes where together we would select the styles to be cut for that season in the appropriate fabrics and colors. And then the

fittings where he would proudly show me the key shapes and have me try on so I could get a first hand feel for the the look, expression, and shape of that season's collection. It was definitely a collaboration one where we trusted and relied on each other's judgment and expertise, and always had fun doing it!!! I adored working with him and always looked forward to his patience and generosity. *Susan Sokol*...........There are so many fond memories of Zack. Some personal conversations, some business conversations, but the thing that comes to mind most is his love of laughter. He loved to laugh. He had a lot of great qualities, but his smile, his laughter for me stands out most in my memory of Zack. Around Zack, no matter how very busy we were, there was time for a laugh. One Christmas he helped us put together a skit that had everyone in stitches as we entertained the staff at our Christmas party. To this day photographs of that event will bring laughs and fond memories. He was talented yet always open to what you had to contribute. I could say "Zack, we need long skirts" and he'd respond with something like—"don't worry, honey, you're gonna have all the long skirts you need!" And end with a high smile and a sparkle in his eyes....That was Zack to me. *Pat Priant*...........Teaching is its own reward! Teaching has been my life for over thirty years—and during that tenure at Parsons School of Design, I was lucky to have as students several talented young men and women who eventually made many of us in NYC very proud—and for two years, among those young people in my classroom, Zack Carr was a real presence...and I was better for him! The young man had impeccable taste...and always challengingly brilliant. I was really quite lucky. Undoubtedly, he helped make me a better teacher. God Bless You, ZC...we miss you still! *Frank Rizzo, Parsons School of Design, Chairman Fashion Design Department 1982-1996*...........Zack Carr was one of the finest people I met while I was fashion editor of *Women's Wear Daily* and *W*. I always looked forward to previewing Calvin Klein's collections because it meant a backroom visit with Zack. While in his workrooms, I would be fascinated with his bulletin board which was crammed with photos, sketches, swatches, and bits of color that represented people, places, and ideas that caught his eye and his interest. Zack and I would talk about this collage of his world and his work. It was fun to see, months later, some remote place or unknown face that he had spotted and pinned to his bulletin board make front page news. Zack not only had a sense of what was new and beautiful, he had a gentleness and kindness that made him stand out as a very special person in our world of fashion. *June Weir*...........Zack's lines say so much...he never went too far. *Donna Berger*...........Zack and his brothers were largely raised in Kerrville, Texas, by my great aunt and uncle, Mae and Sha Patton. Whenever my family would go to Kerrville, we would get together with all our relatives including the Carr boys (Zack, who was then known as Chuck, and his two brothers, Pete and George.) My brother and I loved going to Kerrville for many reasons; one of the reasons we liked going was to be with the Carr boys. The Carrs were a few years older than us and even though they lived in Kerrville (population, at that time, 7,000 plus or minus) and we lived in the big town of Houston (not a city at that time), they seemed much more sophisticated than us. Hanging around the Carrs meant we would have fun and undoubtedly discover things. Perhaps most importantly, the Carr boys were nice guys, and they would not be mean or ignore their younger "cousins." One summer in the early 60's, we all went to Mountain Home, Texas (population probably about 20) just outside of Kerrville for lunch. All our relatives were there. We ate at a motel up on a hill that looked back towards Kerrville. The restaurant was good, you ate outside and there was usually a breeze so you did not melt during lunch. Additionally, there were some activities available to keep young boys occupied. One of the sources of entertainment was a jukebox that played a wide variety of songs. At one point during the time we were there, I talked my dad into letting me have a quarter to play a few songs I recognized on the jukebox. As I was about to deposit the quarter into the machine, Chuck (who then was mostly called Chuckie by all of us) asked me which songs I intended to play. I told him

which ones caught my attention and he immediately started telling me why I should pick two or three different songs by a new group from England who had a number of songs in the top 20 at that time. It was then and there, because of Chuckie, that I heard The Beatles for the first time. Zack was always on the leading edge. He had a sense for it even as a young adolescent in Kerrville, Texas. To me, his sense was not only leading edge but it was also quality, whether it was picking songs by some new group or designing. It was the way he lived his entire life—quality, class and dignity. *Grier Patton*............While I think of Zack often, his intelligence, spirit, and warmth; these are so particular to describe—probably just because there were so many exceptional moments with him. *Robert Pierce*...........Simply put—one of the nicest, funniest people I have ever met. *John Kourakos*........... I had this image of Zack as this incredibly neat and buttoned-up person. Very studious, highly intellectual, and serious in his approach to life and fashion and style. With his almost white hair and sparkling white shirts, never a crease out of place or a dust speck to detract from the black of his jacket, he nonetheless was never intimidating as his smile was captivating. One day, when waiting to see Calvin, Zack came to greet me and have a chat. Paul Cavaco was also there and we got to talking about life and times and the latest exhibitions and restaurants. Then Zack started talking about Studio 54, in a very enthusiastic way, how he missed it, the colors, the lights, the music, the people, and what fun and how exciting it had all been – I admitted that I had only been there once because during those years I had a small child. Paul concurred, as he had been a new father at that time, we traded stories of baby sitters and both felt 'out of the loop'. But the thing was that Zack had surprised me that he had an unbuttoned side as well as being amazingly erudite and scholarly and I will forever remember the glint in his eye when he told us of his 'Disco Nights'. *Patricia Underwood*............The best way I can describe Zack is by a combination of the following. The openly deviant eccentricity and aesthetic decadence of Oscar Wilde, along with his somewhat Greek and inevitable circumstances. The exuberant and immensely flamboyant lust for life of the Auntie Mame character created by the writer Patrick Dennis, whose quote "life is a banquet, and most suckers are starving to death," portrays Zack fittingly. And finally the recurring outcast theme of a Tennessee Williams play. The lead character, a nonconformist, dealing with the destructive impact of the conventional morality of a dominant society. Big themes, even bigger drama, and larger than life characters, that would be Zack. I miss him terribly. *Matt Nye*.............I remember George asking me long ago where Zack had taken me: Zack Carr led me to the doorway of my soul and handed me the key. *Dean Harris*...........My favorite memory of Zack was a quote he wrote me in a book he gave me when I left for Paris—"Search for all the worlds!" *Diana Broussard*...........It was January 26, 1976 when I walked of the 11th floor elevator and began my first day of employment at Calvin Klein Ltd., as it was known at that time. Calvin had three designers working for him then, Jeffery Banks, Charles Suppon, and Zack Carr. I felt like a "rube" those first weeks, coming from a small Pennsylvania town into his sophisticated business of designer fashion and beautiful females, feelings of complete intimidation. Jeffery, Charlie, and Zack could often be seen together in the office or going to lunch together, maybe discussing the upcoming show. And they always seemed to be happy, joking with each other, and never too busy to say hello even to a scared young girl. I was in awe of them. But Zack went one step further. Zack would always offer tips on how the clothes should be worn. He was never condescending, just offering advice on how a certain shirt or jacket would look best. I would see him in the hallway and ask if I was wearing a particular item correctly. Zack would say 'yes' and add an adjustment here or there. But always before he walked away he would leave me with a compliment. That always meant so much to me and eventually this ugly duckling from Pennsylvania didn't feel so ugly anymore. And for as long as I'd see Zack at the office, he always stopped by my office, stick his head in to say, "Hello, how are you, dear?" with that hint of a Texan drawl in his voice.

Today Charlie, is gone, Zack is gone, both too young to be gone. And on occasion I'll run into Jeffery who always has a kind word as well, and inevitably I'll think of sweet Zack. Because of Zack, I no longer fear 6 foot, 110 lbs. beautiful models because he helped me realize I was just as pretty in my own way. Besides I had gotten advice from a master. How could I go wrong? *P. J. Kundar*...........Zack Carr had an obvious faith and love for the Church, especially Saint Thomas Church. It sustained him throughout his illness by giving him the knowledge of Christ in this life and the hope of Eternal Life opening out even beyond death. His faith and love made it an honor and a joy for the clergy of Saint Thomas to minister to him. *Rev. Andrew C. Mead*............I will always remember Zack's sense of innocence For someone who had accomplished so much in an industry known for jaded attitudes, he always showed honest enthusiasm and delight for everything he saw and everyone he met. *James LaForce, LaForce & Stevens*...........It was the late 70's....I was a "young" buyer at Filene's buying this chic new label, Calvin Klein Menswear, and I meet George. Long before it was considered fashionable, we would go to the Ritz for a martini to celebrate our new friendship. And, of course, when you met George you met Zack. What had been routine buying trips to New York now turned into parties with "the boys." After moving to NYC in 1980, we spent many enjoyable times at the W. 15th Street apartment and so typical of the elegant simplicity of the Carrs, our annual Christmas Eve dinner at the Coach House. Even my move to Paris in the early 90's didn't stop "the boys." What fun...a coffee or glass of champagne at the Café Flore, lunch at LaPalette, afternoon field trips to Vaux le Vicomte, shopping for books and berets...Zack always with his camera. But then, the lights of the night....being a little bad, drinking a few too many martinis...that twinkle in Zack's eyes. *Jim O'Rourke*............For me, designers like Zack are the lifeblood of our industry. Supremely talented, in control of his ego, always working for the good of the company and his peers because he loved fashion. That is the kind of legacy few of us leave behind and when the contents of this book are viewed by many for the first time, they will see the poetry of a fashion authentic. *Stan Herman*.............Before any kind of professional relationship, which I had the honor to enjoy with Zack, he was first of all a sincere, intelligent, and generous friend to me. He had an extraordinary talent that he used to express through an unrestrainable imagination combined with a huge fashion knowledge and culture. These qualities had allowed him to perfectly catch all women's needs and tastes—besides being liked by men, women want to like themselves. He was able to draw with total ease. He drew a huge quantity of sketches and he used to do it any moment of the day and on every occasion— while he was talking of art at a restaurant, on vacation on the beach, during an interview, or even in the middle of a business meeting with lawyers! Just as naturally as one can light his cigarette, he would take out his note pad and his pen and suddenly, as if by magic, fill the pages with sketches: jackets, dresses, skirts and coats, all different but all equally simple, sinuous and sensuous. Zack had a deep knowledge of fashion history and such an ability to draw that he could bet himself to draw in one weekend three entire collections of three contemporary "masters." Sketches would flow from his pen and he could express with an extraordinary talent those distinctive features characterizing each of the three masters. They were not just copies of some fashion book reissue, but he could reinvent the shapes giving birth to brand new sketches. He was a sensitive and generous man. Travelling was one of his passions. He didn't care about money, notoriety, and power. Money for him was just a means to live the way he wanted, allowing him to express at the best his imagination and creativity but also to make his neighbor happy. He was cultured, curious, and immensely loved his country. He was proud of being American and was fond of Europe at the same time, its artistic history and its traditions. He had spent a part of his life there; always longing for his country. He was in every respect a "world citizen;" this is probably why after his European experience, he elected New York, the ideal cosmopolitan and multi-ethnic city as his fixed abode. This is where he could enjoy the taste and the

spirit of the entire world. *Roberto Jorio Fili*..........Zack recognized and appreciated style like no one else. A southern gentleman in the true sense–and as a fellow southerner, I know one when I meet one–exceedingly polite and charming with a sly sense of humor. Zack was an original–and that's rare. *Virginia Smith*..........A Love Story: It seemed inevitable that we should meet. After all, I always spent the summer with my grandmother and her best friend, Chuck's Aunt Mae. What began as an innocent friendship in 1960 blossomed into love by 1962–a love that lasted all through our high school years. Of course, the endurance of our romance was helped by the fact that I lived 1500 miles away. Chuck was the boy with whom I practiced French kissing...and we did it until we got it right. He was also the boy who exhorted me to wear my hair in a "French roll" and told me that it was "verrrry" sexy. This boy wrote to me, "Remember this Christmas when people sing and laugh, lovers kiss and caress each other, and bells ring; my thoughts shall be with you. When small but beautiful things happen, will you promise to think of me? When our dreams of beautiful things happen, will you promise to think of me? Our dreams will join us together." This most precious boy also signed all of his letters to me with "I will love you forever and a day." Now, through the wisdom of time and distance, I can see that we fashioned a love that can only be experienced when one is 16...our letters to each other were lusty, romantic and full of longings for a future that would never be ours. This wonderful young man was kind, oddly old-fashioned, generous with himself, occasionally insecure, always humorous and one who knew, early in life, that he was different and destined to follow his heart's desire. During our adult life we kept in touch, but sadly, only in that superficial way of all waning friendships—the Christmas card and the birthday phone call. So this is a portrait of my first love—my Chuck—the boy whom I loved and who loved me; it is my sorrow that I never knew the wonderful man he would become. *Kathleen Carter Livingston*............Zack Carr— All things tasteful and beautiful. All things simple and pure. All things perfect and true. And one "helluva" sense of humor to tolerate what isn't!!!!! *Andrew Volpe*............With a masterful stroke of a brush, with a dab of the perfect color, Zack's power of conveying an emotion through the medium of watercolor could transform the viewer to the scene of where his remembrance took him. Once, years ago, while visiting Zack and John in Milan, we went onto a street market. Zack's excitement for the color of the peppers and eggplants were transformed into sketches with crayon that captured the moment as it was felt earlier in the day. Only a truly gifted artist has that kind of perception. I often think of him while choosing color, fabric, or looking at chic things I know he would appreciate. He was one of a kind, a vanishing breed of shaman and genius who transcended anything. *John Ryman*............This line comes from one of the many letters I received from Zack that he dictated to Nancy from his apartment on 12th Street. "It's another beautiful crystal clear fall day in New York and I wish I was out in it more than ever. I'd love to get dressed and walk down the streets and really live this day." Zack was the most stimulating person I have ever known. He had that indomitable spirit that is ageless...His mind would take off with truly original, perceptive ideas. On one of his trips to visit me after I had moved back to Jamaica, he was staying nearby at Round Hill. I collected him early one morning and we headed off for a day alone together in Treasure Beach, a two hour drive away. We talked the whole way there, we sat by the sea and talked some more, we drank, I don't remember if we even ate or swam, talked the whole way home arriving back to the hotel at sunset, and then proceeded to sit in the car until midnight talking some more. There was always so much to observe and analyze. Those conversations thrilled me—made me really feel I was living this day. The wisdom and insights I received from Zack I have incorporated into my outlook on life, my work, raising my children, the choices I make. I was working on a design project that I felt particularly insecure about. Zack told me that it was one of the plights of creative people that we would always have self doubt. That experience would not necessarily bring confidence because

we were creating and developing new things. In fact, if we ever felt that we had figured it all out we would cease being fresh and original—the self-doubt was part of the process of creativity. *Kathryn Pinto May*............I started working for Calvin Klein only a few short weeks after Zack started working for Calvin. Although it is now almost 30 years ago, I remember that first meeting as though it were yesterday. There was an instant rapport between us over all the things we commonly loved together. Things like Audrey Hepburn, Yves Saint Laurent, Hermes, Bobby Short, Richard Avedon photos, Audrey Hepburn, Gigi, Paris, New York, The Four Seasons, Hubert de Givenchy, Babe Palely, and did I mention Audrey Hepburn? We also found out at that very first meeting that our birthdays were only one day apart with Zack's falling on the 4th of November and mine falling on the 3rd. Thereafter, we considered ourselves brothers. Although separated by a few years and a few hundred miles, Texas and Washington were brought one step closer by this bonding of two Scorpios who were enchanted by the beautiful, elegant, refined wonders that a life in New York Fashion offered. All these many years later it would not be unlike Zack to pick up and continue a discussion started years earlier about the weight of linen used by Givenchy for a daytime tailleur for Audrey as though no time at all had elapsed. It was this consistency meshed with his sweetly abundant charm that combined talent and an eye that was like one of the world's great architects that made Zack such a cherished original. *Jeffrey Banks*...........Talent, professionalism, dedication, discerning taste. Zack possessed all those attributes and used them most effectively in his successful career. But what I remember and admired most was Zack Carr, the man, who charmed everyone with his gracious Southern style, that beautiful and welcoming smile, quick wit, and his kind and gentle manner. *Etta Froio*............Thank you for sharing your creative vision, your stylish clothes, and your provocative humor with beautiful women and men throughout your life...and, most importantly, thank you for sharing your brother George with me. *Denise Seegal*............Thank you for the opportunity to remember your dear brother. We were schoolmates, friends, and yes, rivals. Cheap student dinners in the Village involved lots of confessed adolescent crushes. Zack was years ahead of the rest of us. He wore, with pride, sweaters from Betsey, Bunky and Nini and swell YSL shirts. Mostly I remember his sweet smile. *Alastair McRobbie*............The strength of a person is sometimes fully realized by a momentary glance into their soul. Zack's life as a real designer was committed to reassessing every element of his surroundings. Though he chose to address and focus on fashion, he was an inspired, educated, creative person driven by a never ending thirst for knowledge and culture, and through his studies, was outspoken and eloquent on all subjects. As with many truly creative people, there were moments where one would be aware of tremendous despair that the human endeavor was never going to be fully realized and that he would perhaps never achieve the complete desired result that was in his minds' eye. We spoke of this frustration often and he never seemed to be able to get close enough to the monster to even think of how to attack it. However, there was one moment that stands out as a treasured second in the years that we knew each other, a profound instant where I saw Zack at peace with himself and his God. I was seated with Zack and his collaborator Sarah Lord at the Le Cherche Midi in Paris on an early spring day. There had been a tremendous thunderstorm during our lunch. The sky to the west suddenly cleared in an instant, permitting a blast of low gold sunlight to strike the buildings on the curve of the street to the east. The wet facade of the buildings were glazed as though dipped in a varnish of gold against a black gray sky of the passing storm. The light came so suddenly that we all turned simultaneously to look at the reflection on the structures and then speechlessly we looked into each other's eyes that were filled with tears. I will always remember Zack's tender look of total peace that here in his personal struggle for perfection was a moment of such complete and perfect design though not created by his hand or soul was realized and cherished by his soul. I will always remember him in this profound silence.

I will always remember him in the light of Paris. *Tom Penn*..........Zack (Chuck) came home after graduation from UT in Austin, Texas. Martin and I had just bought a new home in Kerrville, Texas. I had a new black vinyl sofa–so proud of it. I needed something to hang above it. (So, I have a lot of nerve.) I asked Zack to make me something to go with the black color. He made a collage—just perfect for what I wanted. He spent a lot of time on it. Zack and I went to Lehman's Dime Store and found a frame for it. Later on, I could buy a painting–so sorry–now I wish I still had Zack's collage. His first commission piece—no charge. *Cornelia Stehling (Zack's mother is my first cousin)*............ If there was one person who really understood the word "beautiful," it was Zack. *Joe McKenna*............Zack was a master of that most ephemeral art, conversation. I can picture him across the dinner table, eyes lit and far away, retelling (or reliving) the story of a morning in North Africa. He had climbed to the flat roof of his house to watch the sun rise (why he was up at dawn is another story). His rooftop, like all the houses of that village, was made from the local mud, which was a deep pink light, pale and soft in the early dawn (experience of being enveloped by reflected pink light, pale and soft in the early dawn) progressively intense and luminous as the sun rose. It could have been anyone's lovely travel souvenir, I suppose, but Zack's description made it vivid and magical. That pink spectacle seemed to match the epic sense of beauty he felt personally and always tried to express materially. His weren't the observations of a detached aesthete. Rather, Zack seemed to yearn for tangible, physical manifestations to match the beauty, joy and pleasure that was his experience of a life lived well. It was always such a treat to be offered a glimpse of the world through Zack's eyes. *T.J. Wilcox*............I knew Zack for over 20 years. Starting back in the late 70's I got my first job in the industry at Calvin Klein Menswear. It was there that I first met George, Zack's brother, and through becoming friends with George, I met Zack. In later years, I would work directly with Zack again at Calvin Klein. So I knew him in varying capacities. In all the varied facets of Zack's personality, as great as Zack's talent was and as wonderful as he was to work with, I believe that his greatest role was as brother to George. I saw the love that he had for his younger brother. I watched Zack as he counseled George, guarded and protected him, and occasionally frowned on the antics that George and I would pull! But always there was the brotherly and "motherly" love. The bond that these two men shared as blood brothers and as co-workers in the same industry was very special. I envy George having had an older brother like Zack. *Randy Fields*............Zack was a source of great inspiration to many of us…he was the teacher, the advisor, the confidant, the fantasy…his vision was endless and his love of design and fashion a part of everything he did…he was a refined and lovely man that I was fortunate to know.... *Lynn Tesoro*............Near the end of our senior year as fashion majors at Parsons, Zack said: "I have to design something every single day or I don't feel normal." I was quite taken aback by this statement as the rest of us left homework for the night before it was due and focused on meeting deadlines throughout the week on all the other skill related tasks in other classes. I have relayed this quote over and over again to our fashion students at Otis. That they not lose touch with their passion and purpose for being in school in the first place to be a designer. Also, that their work will be so much better as a result of "developing" over the course of days rather than last minute. Zack Carr's passion to put ideas on paper daily, (aside from also being gifted), was why he could design us all under the table. *Rosemary Brantley, Chair, Otis College of Art & Design, School of Fashion, Los Angeles, CA*............Zack was brilliantly talented, had an unerring eye, and the kindest heart—a rare combination. *Michael Kors*............While an in-patient, he was feeling 'down' (this was about the first time I'd seen him give in) due to the fact he was feeling poorly as well as being aware of his diagnosis. I was aware that he was a talented designer so I suggested to him that he draw and I gave him a little 4 x 5 pad that I had carried to jot down notes. I came back a couple of hours later and asked to see what he had done and was informed that he had no pencil!! Anyhow, I provided the pencil and the next

day he showed me about 25 drawings of exquisite dresses that left me speechless, he started laughing and asked whether I wanted to have one made up for me!! We both felt good that day. Zack realized that he still 'had it' and for me it was a refreshing change of my daily hum-drum routine. *Lillian Reich, MD*............Zack was an original, as distinct as the countless designs he created. He was blessed with a passionate sense of what he wanted to do and the talent and energy to exploit that passion to the fullest. A dreamer with a difference, he had the skill and discipline to turn his visions into wearable realities, which he masterminded down to the last detail. I knew as soon as I met Zack, when he was just starting out, that he possessed a unique sensibility. I remember when he opened the door to his tiny apartment on Grove Street and I was confronted with that spectacular furniture—a red lacquered table with legs that began as elephant heads and gracefully tapered to the floor, and an intricately carved poster bed fit for a maharajah. These were products of Zack's imagination which he had realized in India, no matter that he almost succumbed to dysentery in the process. I have secretly coveted those pieces all these many years. Zack's designs bore his own indelible stamp and reflected all the things that made him tick. The pattern of a Moroccan tile, a tree in a Georgia O'Keeffe painting, the color of a Central Asian ikat, an image from a Matisse cut out. All of these were an integral part of his artistic language. He found inspiration and adventure in the souks of far away places, the streets of New York, and the pages of long-forgotten books. Although fashion was Zack's professional calling, his sense of style and beauty extended to everything he touched, even the most mundane. One time when I went for brunch to his apartment–which by now was in a different Village location and had been transformed from Indian exoticism to Corbusier chic—he served omelets with ginger. I hate eggs. (Of course, he didn't know that.) So visually delicious was the repast, however, that I believed they tasted as good as they looked and ate up with gusto. The range of his vocabulary was evident in the clothes he brought to life–from the ethnic luxe of the 70's to the cool, but sensual, minimalism of the new millennium. Throughout, there was a consistent design philosophy–a refinement of style, a clarity of line, and an appreciation of the subtle nuances of cut and shape that spoke with a quiet authority. I loved them all and, to this day, I always feel special wearing them. *Sylvia Shaprio*............Zack and I worked together for many years at Calvin. The design studio was small then and steeped in talent and energy. As I look back now we were a family of sorts and Zack was clearly the center. His style, his taste, and his elegance set the tone for all of our work. And work we did. Under Zack's guidance we produced the most prolific designs and concepts. Zack was involved in everything. He could bring out the best in all of us. He was and is truly inspiring and greatly missed today. I shall always cherish my times with him. *Barbara Warner*.............My story about Zack is from three years ago. I had been teaching at Hofstra Law School for the week. One night I came in to meet Zack at a restaurant in Manhattan and brought a young black lady who lived in Manhattan and was also teaching trial advocacy with me on Long Island. She was a tall model type and happy to meet Zack. Zack was already there and knew the owners and regulars. He was generous and gracious as always and we talked about how he might someday take over even more responsibility for Calvin Klein. What I cherish about the conversation was how Zack flattered me and made me feel important. Zack talked about my intellect and said that I was just being amused at their interchange in our conversation. This was all an exaggeration but it reminded me for the first time in what seems like years that I myself once had my own high opinion of my own abilities. I have not yet come down from Zack's praise and I remember as if yesterday how special he made me feel. This was a special gift among Zack's many special gifts. *Scott Stehling*............Zack was a great storyteller. He always had the best stories as we sat around his house drinking wine and eating Moroccan food. Stories of Kate Moss and Gary Oldman; the first time he met Calvin and how they both were wearing the same jacket, in the same color! He told me he knew that *"it would be*

a wild ride." I remember his 50th birthday party with so many chiseled models attending along with Cameron Diaz and Marisa Tomei. Everyone loved Zack! Zack was funny and generous and had a strong passion for life and a zest for living it. *Victoria George*............Zack Carr is, for me, a true inspiration—a master creator who invented a language in clothing that would become the definition of what is modern, while subtly, beautifully transcending the conventional ideas of fashion. He changed and refined luxurious, sensual, "clean" clothes forever. And if those immense gifts weren't enough, he was also an extremely brilliant, kind, and generous man with a devilish sense of humor and a beautiful, artistic soul. His magic is always with us. *Max X. Wilson*............I send you my deepest condolences for your brother Zack. It must be hard to loose someone so close to you. I started crying when Jackie told me the news. Zack was truly one of my biggest mentors. I think it is wonderful what you are doing with his sketches, I can just picture him with his Hermes "croquis books" and hear him talk about all the places. This was Zack's greatest gift to me, visualizing places and finding the vivid imagination within myself and design from there. He also taught me about fashion, sophistication and tailoring and I can honestly say that his inspiration followed me to Gucci and then onto the La Perls. I still hold on to places in New York, Café Felix and Raoul's, where Zack took me and we would spend many moments together. What I regret the most is not to have seen him before he passed away, but in my heart I said goodbye to him. My husband Palli and I still talk about him, the wonderful little parties on his balcony, and Palli can still see what I learned from Zack. *Steinunn Sigurd*............I remember going with my sister Tonne to Zack's house for dinner. Just the three of us in his cozy, ordered apartment. The fire was lit when we came in and there was champagne chilling in a silver bucket and I felt that I had melted into this gorgeous dream where the three of us never stopped talking once. I wandered around studying each fantastic photograph and after dinner when the fire was down to an orange glow, Zack brought out one of his sketch books and the evening started all over again. Oh, to remember such happy wonderful times! *Wendy Goodman*..............March, a charming model with whom I worked for years posed for an ad in a handsome Calvin Klein double-breasted camel hair coat. She loved it and Calvin kindly arranged for her to have it at much less than the extravagant store price. The following season, John Fairchild and I went to see Zack and Calvin for an advance look at the next collection and the atmosphere was so casual that I risked quoting March and said "You know, Calvin, all the buttons fall off your coats." Zack, gracefully Southern, said "Yes we know, but we've solved that problem now. We make only wrap coats." *Kenneth Paul Block*............I knew Zack for years before he was sick, as a designer and artist. During the last couple of years of his life, to the actual moment of his death, I knew Zack as a man. A man determined to live life to it's fullest, though his physical capacity was now limited. He extracted every bit of pleasure he could out of life. From the experience of feeling the afternoon sunlight cross his body, to watching the smoke from a cigarette twirling in a breeze, to inviting two boys over for lunch that, seemingly, never quite liked each other, but actually, competed for his attention. He accepted the truth about who he was and the truth about his cancer. Somehow he found a way to integrate the experience as part of his life. Even when his hands stopped him from his greatest pleasure of drawing, he fought with the greatest courage to maintain this truth of life with dignity and appreciation. Zack cared for everyone no matter where they came from or who they knew or didn't know or what they did for a living. At the end, he heard us laughing, after five days of standing by his bedside at the hospital. He died at that moment, knowing we would all be O.K. The most important thing I learned from Zack is that beauty exists through truth and awareness. *Gregory Bissonnette*............While shopping in London with Zack just before the launch of the Home Collection, we had just finished exploring the Burlington Arcade. Feeling the need for mid-afternoon refreshment, Zack suggested we have tea at the Ritz. So off we went in keen anticipation. On arrival, our entry was graciously

declined; we were not wearing ties. Zack, with great civility, apologized and said we would return in ten minutes. We left the Hotel and headed for Simpsons where we purchased Oxford striped ties and returned to the Ritz. The maitre'd proceeded to seat us and quietly said to Zack "Good choice, Sir." And that was Zack: he always made good choices. *Marc Hacker*..............When Zack blew into the office in a twirl and said, "Sorry I'm late ya'all!" it prompted me to say, "Scarlett, however did you manage to fit your hoop skirt into the back of the taxi cab this morning?" From then on, "Scarlett" became my affectionate nickname for him. And he loved it. Zack's humor and generosity will stay with me forever. *Narciso Rodriguez*............I met Zack on the first day I came to work at Calvin's back in early 1990. We sat down to look at some fabrics. I remember my nervousness as he pulled rrrrrrighttt up to me, so close, touching actually, and then I noticed we were wearing the same glasses. The first thing he said, with that smiling light-in-his-eyes, was "We are going to be great friends." Just how true that would be and how big the hole his passing would leave in me I had no idea. Thinking now of the space Zack filled, of course one of the first things to come to mind is his incredibly intense, inspired vision...the clarity in his perceptions...his ability to continually absorb from all the stimulae around him an impulse which he could then transform so immediately into a new idea, color, shape. He drank it all in and gave it all back translated through the lens of his extraordinary vision. But more than that fine, rare talent is the special man he was. Never have I had a friend with such deep-hued qualities: brilliance, intensity, passion, complexity, warmth, will, inspiration, generosity, sensitivity, depth spirituality, taste, culture...and along with those, an excessive thirst for beauty fueled by such searing angst. It is painfully hard to truly portray the impact of Zack on me, so in place of that I offer this scattered remembrance, a mere glimpse, a scene from a life with Zack as my friend: The moment of being one of the 'katzenjammer kids':...when the weather finally turned from winter to spring, there would be that one glorious warm sunny day when the phone would ring and I would hear Zack's voice purring in my ear, saying "Sarah," (in that particular southern Texan lilt of his) and then down to Soho, ending up in a late leisurely sidewalk lunch drinking kirs, jabbering away, laughing and feeling as if in some exotic distant place...feeling oh so naughty, so free in those stolen moments...moments in which, along him, I too basked in being one those he referred to as the 'katzenjammer kids'...In the empty space his passing has left in so many of us, these words echo so true: '...now take back the soul of Zack Carr whom you have shared with us. He brought us joy and we loved him well. He was not ours, he was not mine.' From the movie, *Out of Africa*. *Sarah Lord*...........Working with Zack was one of the most unique experiences of my professional career. Never before had I known anyone who was so observant of the world around him. He connected to art, literature, psychology and retained a childlike wonder about life, all of which accounted for his humanitarian approach to life. Zack truly affected my life and I am honored to have known him. *Dr. Terrence O'Sullivan*...........On December 21, 2000, my brother Zack Carr after a long illness passed away. Zack's family, friends, and loved ones came together on Christmas Eve Day in Kerrville, Texas, Zack's hometown, to mourn his passing, and to celebrate his life. At this gathering, I, Peter Carr, shared a few thoughts and feelings about my brother: "I would like to thank everyone for being here today to celebrate the life of a truly beautiful man. A man who was very gentle, and yet the strongest man I have ever known. Zack was an artist. He brought beauty into the world, and into the lives of countless people. Zack had not resided in Kerrville for over 35 years and still over 150 friends have come here on Christmas Eve to say good-bye. I never knew Zack to raise his voice or show anger to anyone. His kindness and compassion for all people was always a part of him. He truly loved people and was truly loved by people. It was not his position in life that impressed people, but who he was as a person. He was my closest and dearest friend. He will be missed." Farewell sweet brother, we will be together again. *Peter Carr*............

Left: Zack Carr Collection, New York, mid 1980's
Right: Mamounia Hotel, Marrakech, Morocco, early 1980's, by John Calcagno

Man, Zack Carr sketchbook, early 1990's

love...brothers, Zack Carr sketchbook, early 1990's

Luis Barragán, John, and Zack, Mexico City, Mexico, early 1980's, by Bruce Weber

Brookhaven Cottage, Long Island, New York, 1990's

Left: Brookhaven Cottage, Long Island, New York, 1990's Right: Aloysius, Bellport House, New York, early 1980's, by John Calcagno

Left: Cottage Kitchen, Brookhaven, Long Island, New York, early 1990's Right: Backyard, Brookhaven, Long Island, New York, 1990's

Monday or Tuesday, Oil on canvas, 54" x 68", 1993, by Duncan Hannah

Left: Silhouette, Houston, Texas, 1952 Right: "The Boys", Kerrville, Texas, early 1950's, by J.D. Patton; Mother and Zack, Houston, 1945, by Zack Carr Jr.; Sketch for Aunt Mae, New York, 1970's, by Zack Carr

Horses for Barry and Sheryl, New York, 1980's, by Zack Carr

Left: Camellia, Detail of Zack Carr Collection, New York, 1986, by Hiroshi Kazo Right: Cat, New York, 1990's, by Narciso Rodriguez; Grace's Cat, East Hampton, New York, 1990's, by Grace Coddington; Calla lillies, New York, 1990's

Left: Zack Carr, Parsons, NY, early 1970's, by Ken Duncan; Zack and Zack, Houston, TX, 1989 Right: Zack Carr, NY, 1986, *Women's Wear Daily*; Zack and Carolyn, Lucky Strike, NY, early 1990's; Zack Carr, Calvin Klein Studio, NY, 1990's

Zack and Corky, Bronx Zoo, New York, early 1970's, by Ken Ohara

Zack Carr, Morocco, early 1990's, by John Calcagno

Left: Henri Matisse Right: Alberto Modigliani, Auguste Rodin, Anonymous artist

Zack Carr Collection, sketchbook, New York, mid 1980's

Zack Carr Collection, sketchbook, late 1990's

Zack Carr Collection, sketchbook, late 1990's

Left: Watercolor, by Georges Braque Right: Zack Carr Collection, sketchbook, mid 1980's

Zack Carr Collection, sketchbook, mid 1980's

Left: Zack Carr Collection, sketchbook, mid 1980's Right: René Bouché sketches, cut from magazines

Zack Carr Collection, sketchbook, late 1990's

Brookhaven Cottage, Long Island, New York, 1990's, by Stuart Shining

No. 11C, 59 West 12th street, New York, late 1990's, by Hiroshi Kazo

Peonies, 59 West 12th street, New York, late 1990's, by Zack Carr

Zack Carr, Florent, New York, early 1990's, by Robert Pierce

Romy Schneider, Rue Cambon, Paris, early 1960's, *Life Magazine* article

Zack Carr, sketchbook, 1990's

Zack Carr Collection, sketchbook, 1990's

Zack Carr Collection, sketchbook, 1990's

Left: Taos, New Mexico, *Harper's Bazaar*, 1940's, by Louise Dahl-Wolfe **Right**: John, Marrakech, Morocco, 1977, by Zack Carr

Zack Carr, Palais Saram Hotel, Taroudant, Morocco, 1977, by John Calcagno

Zack Carr, Barbados, 1978, by John Calcagno

Backyard, Brookhaven Cottage, Long Island, New York, early 1990's, by Zack Carr

"Buster," Brookhaven, Long Island, New York, 1990's, by Gianluigi Tacchi

Zack Carr, early 1980's, by John Calcagno

Zack Carr, Tangier, Morocco, 1980's, by John Calcagno

Zack and Grace, Medina, Morocco, early 1980's, by John Calcagno

Left: Istanbul, Turkey, mid 1990's, by Zack Carr **Right**: Marrakech, Morocco, 1980's, by Zack Carr

Collage with James Dean, Sal Mineo and Nuryev, collected art; two guys standing, by Bruce Weber

Left: Zack Carr sketchbook, 1990's **Right**: Statue, Rome, Italy

Zack Carr sketchbook, 1990's

Zack Carr sketchbook, 1990's

Left: Chanel sketch, by René Bouché; Balenciaga sketch, by René Bouché **Right**: Zack Carr sketchbook, 1990's

Zack Carr sketchbook, 1990's

Zack Carr sketchbook, 1990's

Audrey Hepburn, 1963, by Bert Stern

Zack Carr Collection, sketchbook, 1990's

Zack Carr Collection, sketchbook, 1990's

Zack Carr Collection, sketchbook, 1986

Zack Carr Collection Showroom, New York, mid 1980's, B Five Studio LLP, Ronald D. Bentley, Salvatore V. LaRosa, Franklin J. Salasky, photo by Paul Warchol

Zack Carr Collection Ads, New York, 1986, by Fabrizio Ferri

Left: Zack Carr Collection, sketchbook, 1990's **Right**: Leaf from O'Keeffe's house, Abiquiu New Mexico, early 1980's, by Zack Carr

Zack Carr Collection, sketchbook, 1990's

Left: Moroccan Men, Morocco, Zack Carr sketchbook, early 1970's **Right**: Grace Coddington, Mamounia Hotel, Marrakech, Morocco, early 1980's, by John Calcagno

Zack and Grace, Mamounia, Marrakech, Morocco, early 1980's, by John Calcagno

Gatefold flaps: Zack Carr Collection, sketchbook, late 1990's

Inside Gatefold: Zack Carr Collection, sketchbook, late 1990's

Zack Carr Collection, sketchbook, 1988

Calvin, Zack, and Kelly, New York, 1990's

Zack, Calvin, and John, Santorini, Greece, early 1980's, by Kelly Klein

Zack, Kelly, and Iman, Santorini, Greece, early 1980's, by Kelly Klein

Zack Carr Photography Collection, New York, mid 1990's

Kenneth Paul Block and Zack Carr, Metropolitan Museum of Art Costume Gala, New York, late 1970's

Zack Carr Photography Collection, New York, 1970's–1990's

Zack Carr Photography Collection, New York, 1990's

Zack and Marina Schiano, Zack Carr Photography Collection, New York, early 1990's

Zack Carr Photography Collection, New York, 1980's–1990's

Tonne, Virginia, Gianluigi, and Tasha, Zack Carr Photography Collection, New York, 1990's

Zack Carr Photography Collection, New York, 1990's

Left: *Your Brother*, Los Angeles, California, late 1990's, by Ken Ohara **Right**: Zack and George, the Bosphorous, 1990's

Left: Zack Carr sketchbook, 1990's **Right**: Sam and Jessica, by Bruce Weber

Zack Carr sketchbook, 1990's

Zack Carr sketchbook, 1990's

Birthday at The Odeon, New York, late 1990's

Frank Lloyd Wright, Los Angeles, California, 1997, by Zack Carr

18 South Howell's Point Road, Long Island, New York, early 1980's, by John Calcagno

18 South Howell's Point Road, Long Island, New York, Early 1980's, by John Calcagno

18 South Howell's Point Road, Long Island, New York, early 1980's, by John Calcagno

70 West 11th Street, New York, mid 1980's, by John Calcagno

70 West 11th Street, New York, mid 1980's, by John Calcagno

Forever, Los Angeles, California, 1999, by Chris Prince

Zack Carr Collection, sketchbook, 1990's

Left: *Marina,* New York, 1990's, by Marina Schiano
Right: Zack Carr sketchbook, late 1990's

Zack Carr sketchbook, 1990's

Zack Carr sketchbook, 1990's

Left: Zack Carr, Jerpa, Tunisia, 1980's, by John Calcagno **Right**: Canoe, by Hiroshi Kazo

Zack at Edward Weston's, Carmel, California, early 1980's, by John Calcagno

Acknowledgements

Calvin Klein, Kelly Klein, Barry & Sheryl Schwartz, Anna Wintour, Grace Coddington,

Patrick McCarthy, Bruce Weber, Nan Bush, Isabella Rossellini, Marina Schiano,

John Calcagno, Gwyneth Paltrow, Timothy Gunn, Denise Seegal, Frank Rizzo, Marie Essex,

Andrew Volpe, Theodore Barber, Clinton Kuopus, Rosemary Brantley,

Rev. Canon Harry E. Krauss, Lillian Reich MD, Bridget Foley, Amy Spindler, Robert Hofler,

Lynn Tesoro, Victoria George, Isabelle Kellogg, Nancy Glazer, Michael Berkowitz,

David Hutchings, Sarah Lord, Dean Harris, Gregory Bissonnett, Robert Page,

Jeffrey Banks, Matt Nye, Jim O'Rourke, Nicholas Tonnelier, Matt Ullian, Elizabeth Rogers,

Monica Hansen Teele, Rachel DiCarlo, Virginia Smith, Salvatore V. LaRosa,

Ronald D. Bentley, Franklin J. Salasky, Paul Warchol, Bert Stern, Stuart Shining, Hiroshi Kazo,

Ken Ohara, Ken Duncan, Fabrizio Ferri, Duncan Hannah, Gianluigi Tacchi,

Chris Prince, Robert Pierce, Scott Stehling, Cornelia Stehling, Kathleen Carter Livingston,

Beverly Sullivan, Camille Patton, Sylvia Shapiro, Richard Owens,

Jan Gerrard, Mike Mitchell, Brad Steinbauer, Zorick Parsanian, Armen Vartanian,

Craig Cohen, Sara Rosen, Kristian Orozco, Betty Eng, and Sam Shahid

Parsons School of Design

Shahid & Company

powerHouse Books

Saint Thomas Church, Fifth Avenue

Memorial Sloan-Kettering Cancer Center

Memorial Sloan-Kettering Cancer Center gratefully accepts donations in memory of Zack Carr.

To Mother

Zack Carr

© 2002 powerHouse Cultural Entertainment, Inc.

Artworks and writings by Zack Carr © 2002 George Carr, Veritas Productions/Trustee, Zack Carr Foundation
Additional artworks and text © 2002 René Bouché, John Calcagno, Grace Coddington, Louise Dahl-Wolfe,
Ken Duncan, Fabrizio Ferri, Duncan Hannah, Hiroshi Kazo, Kelly Klein, Ken Ohara, Robert Pierce,
Chris Prince, Narciso Rodriguez, Marina Schiano, Stuart Shining, Bert Stern, Gianluigi Tacchi, Paul Warchol, Bruce Weber

All right reserved. No part of this book may be reproduced in any manner or transmitted by any means
whatsoever, electronic or mechanical (including photocopy, film or video recording, Internet posting,
of any other information storage and retrieval system) without the prior written permission of the publisher.

Published in the United States by powerHouse Books, a division of powerHouse Cultural Entertainment, Inc.
180 Varick Street, Suite 1302, New York NY 10014-4606 telephone 212 604 9074 fax 212 366 5247
e-mail zackcarr@powerHouseBooks.com web site www.powerHouseBooks.com

First edition, 2002

Library of Congress Cataloging-in-Publication Data:

Carr, George.
 Zack Carr / by George Carr ; art direction by Sam Shahid.
 p. cm.
 Exhibition at the Parsons School of Design (November 2002)
 ISBN 1-57687-155-X
 1. Costume design--United States--History--20th century--Exhibitions. 2. Fashion
 designers--United States--Exhibitions. 3. Carr, Zack--Exhibitions. I. Parsons School of
 Design. II. Title
 TT502.C377 2002
 746.9'2'092--dc21
 2002068430

Hardcover ISBN 1-57687-155-X
Separations, printing, and binding by Steidl, Göttingen
The Zack Carr papers and sketches are held by The Anna-Maria and Stephen Kellen Archives of Parsons School of Design,
New School University, New York City, New York, www.newschool.edu
A complete catalog of powerHouse Books and Limited Editions is available upon request;
please call, write, or visit our web site.
10 9 8 7 6 5 4 3 2 1
Printed and bound in Germany

Art Direction by Sam Shahid